DOING TIME
ESSAYS ON USING PEOPLE

KRISTIAN VISTRUP MADSEN

FLOATING OPERA PRESS

Editor: Aaron Bogart

Copyediting: Rosanna Mclaughlin
Proofreading: Julie Astor
Graphic design: Dan Solbach, Robin Brass
Typeface: Quadrant Text, Vincent Chan (Matter of Sorts)
Printing: Graphius, Ghent

Published by
Floating Opera Press
Hasenheide 9
10967 Berlin
www.floatingoperapress.com

ISBN 978-3-9819108-4-1
Printed in Belgium

TABLE OF CONTENTS

CHAPTER 1
Drunk in the Trenches

When I arrived in London in 2011, I had a flip phone and didn't own sneakers. I'd tell people I didn't use the Internet, and I wasn't exactly lying. I grew up somewhere small and isolated in Denmark. Or it felt that way to me. Anything important or urgent or new seemed to come to us from somewhere else. I moved to London because I wanted to be at the center of cultural production; because only at the center can you stop investing in it. That's also why I went to Goldsmiths. I had understood that it was a good place to experiment with boundaries; to disregard what art, literature, culture, and even politics was. To the extent that this proved to be true, it brought up some serious questions it has taken me the better part of a decade to unpack.

As the UK's higher education system was reformed into collapse, I spent three years in south London reading up on the "posts"—from modernism through structuralism, humanism, feminism, and colonialism—looking everywhere for "subversive potential." I found it in indulgence and withdrawal, silence, mimicry, and illegibility, but I also found myself attaching moderators like "gesture," while "potential" mysteriously became "potentiality." Freud was post, the Internet was post, gender was post. I handed in a Tumblr blog about "archiving absence" as an essay. It concerned the materiality of what isn't there with the aim of unraveling the very notion of the archive itself. On the one hand, it would seem that nothing was left; that deconstruction had no limits, and the layers of power could be peeled back until only language remained; that the endpoint of postmodernism's famous "anything goes" might just be nothing at all. But on the other, the contours of new dogmas began to emerge: a hierarchy of oppressions, a re-politicization of culture that didn't yet feel like piety, but from the outset was deeply skeptical of art, and seemed to work against it. The "nothing," it turned out, was political.

The writer Chris Kraus once said that you can't be successful in the art world unless you hate art. By that measure,

when I started my master's program in Critical Writing at the Royal College of Art in 2014, I was well on my way to becoming successful in the art world. I thought: If the most requested library book in political science was Judith Butler's *Gender Trouble*, as it had been in my department at Goldsmiths, the world probably wouldn't look the way it does. If the European governments practiced the same politics as the artists they sent to represent them at the 2015 Venice Biennale, probably less bodies would wash up on Mediterranean beaches. Art, it seemed to me, was not only a failure but a decoy. I asked: Is the art world the hand sanitizer of The Man? Can political art affect change, or does it stop at masking the absence of it?

In many ways, what had taught me to hate art was the endless quest for art to be subversive of something other than its own form, or, failing that, to simply subvert itself—that is, implode; culture workers pulling at the rug underneath it. This is the modus operandi of identity politics, what Eve Kosofsky Sedgwick, borrowing from Paul Ricœur, calls the "hermeneutics of suspicion"—in short, exposure as method. The years I spent at Goldsmiths coincided with the reemergence of identity politics into the mainstream. Based as it is on calling out the oppression of certain aspects of identity, it is easy to see how identity politics relies on the continued inscription of these oppressions for its very sustenance. There's no small amount of masochism involved in this maneuver. The focus on representation and revelation is also not unequivocally helpful to, as Wendy Brown writes, "social formations in which visibility itself constitutes much of the violence." At the same time, as we know, *Silence = Death*. Here is a double bind.

Brown names this commitment to the continued inscription of oppression "wounded attachments." She recalls Friedrich Nietzsche's assertion that "only that which never ceases to *hurt* stays in the memory," and, conversely, Thomas Mann's "craving for freedom, release, forgetfulness." Butler agrees in defining the concept of performativity, so central

to that of identity, as the painful repetition of norms. "This is not freedom," she writes, "but a question of how to work the trap that one is inevitably in." For Sedgwick, the hermeneutics of suspicion is an expression of paranoia; a neurotic return to the memory of pain.

All these thinkers locate their critique of identity politics around its attachment to a wound, a fetish for pain. The question, then, is how to relate to this wound, so undeniably there; how and when to indulge in pain or exercise care, and what these strategies can do for us politically. It's a question of memory and forgetting, freedom, release, and reparation.

*

The last summer I was at Goldsmiths in 2014, the university hosted a conference on Radical Negativity—the idea that negative states of feeling can be emancipatory or empowering. I was way into it—I think I tweeted most of it. "But what if sometimes you just feel like shit?" someone raised their hand and asked. There was no answer. Beneath our excitement it was pretty clear that this new negative dialectic was not enough to motivate a whole existence.

At the Royal College of Art, the conversation was somewhere else. When, in one of the first lectures, the professor was asked to explain what she meant by "quasi-Adornian," she might have referred to that summer's conference, but gave up when she understood she had to start with "quasi." Art was back on the curriculum in the good old-fashioned way, and so my hatred of it had to become more constructive in order for my presence at the esteemed Kensington address to make sense. That's when I began an active inquiry into its limitations; asking an honest question about art's political potential, what it makes sense to ask it to do.

In 2015, I did a substantial so-called cultural archeology project about an ambitious art-poster campaign organized by the Goethe Institut in 1993. Titled *I AM YOU*, works by

twenty-five famous international artists were widely exhibited on billboards in public space in response to a series of violent attacks on asylum centers and refugee shelters in Germany after reunification. The fundamental problem that I saw with the campaign is implied by the erasure of difference evident in its title: Am I really you? Could I possibly be? The posters ranged from similar regurgitations of well-meaning platitudes to completely illegible abstractions. I will admit that I actually liked quite a few of the works, and spent a long time with them—also that I have since begun to forgive *I AM YOU* for its shortcomings. But, in Sedgwick's terms, I was paranoid; eager to prove my worth as a critic by lashing out, but also eager to find a way out of the double bind. I hinged my closing argument on this quote from Susan Sontag: "This cooption of the idea of revolution by the arts has introduced some dangerous confusions and encouraged misleading hopes."

Sontag laid out this hard line in the introduction to a 1970 book of posters from the Cuban revolution, which would do exactly what she argued against and disseminate aestheticizations of radical political ideas among an elite. Here Sontag made the only sustainable choice available and confronted the necessary paradox of participating in cultural production: she wrote the text anyway.

*

As teenagers in Denmark in the late 2000s, we were skeptical of identity. Liberalism being on the Right of the political spectrum, and my friends and I with the socialists on the Left, we saw in it a dangerous fracturing of the working class, too much lifestyle and too much narcissism. The figure of authority in our group never cut his almost seethrough blond hair and changed between two sweatshirts: one of Che Guevara and one that said "Save Christiania"—a consistently threatened Copenhagen hippie commune where

we got our weed. Even amid this caricature, identity was not for us. My own homosexuality was a coincidence, like having freckles. We didn't know any brown people. I didn't know how desperate I was to leave until I did.

In this approach we were the perfect subjects of liberal democracy, insofar as, according to Brown, the universal "we" of liberal democracy requires "that the constituent terms of the 'I' remain un-politicized." She specifies that the political un-articulation of the "I" happens either through trivializing difference or accepting its construction as a supplement to the "we." I remember well the seduction of that uncomplicated "we"; the Scandinavian social-democratic concept of the state as "the people's home"; a place to belong and be safe. But this safety is facilitated entirely by homogenization and exclusion, as the rise of nationalism—that other, frumpier, and more efficient brand of identity politics—will quickly remind us. If only Left-wing identity politics hadn't been just as quick to give up on the dream that it is possible to have one without the other.

Fast forward to 2013 and politics seemed completely overwhelmed by identity. These were my Goldsmiths years: Sara Ahmed was the most celebrated academic on campus, Beyoncé the most famous feminist in the world, Miley Cyrus's MTV performance was an important political event, and the selfie, word of the year, was hailed as a mode of subversion.

I sat at the pub on the corner opposite the library full to the brim with a feeling of injustice in the world. Leffe sat next to me, shaved head, rhinestones glued to her face. She made narrow ceramic cups that looked like vaginas; she gave me my only tattoo, and she glowed as if the source of all life. My insides were boiling with the shock of history—I was probably writing one of my essays on postcolonial literature—and said, why not be as politically radical as you possibly can? Everything is so fucked up, so entirely rotten to the core—I raised my glass—*why the hell not?* We could think of no reason. Leffe lived in a squat routinely raided by the

13

police and was involved in community organizing. That night I signed up to help out in any possible way. I wore a sand-colored trench and brought flowers back from the market on the weekend. I would be a kind of Trojan horse, we imagined. There was nothing that I wouldn't do.

When I think of that time I think of our rugged Victorian terrace and how, on more than one occasion, the zeitgeist showed up at our door in what seemed like hundreds. The large unkempt garden was crawling with health goths not yet vaping, new-new romantics doing Ket in the bathtub, two-for-five-pound bottles of red and the last of American Apparel's metallic spandex. One night, some straight guys managed to find a guitar. Three chords into "Wonderwall" they were surrounded by a mob of lesbians who put them in their place: not here. Times had changed.

Downstairs in the kitchen another conflict was erupting. Provoked by a Jewish American's claim to otherness, a Norwegian adoptee of indigenous Colombian descent confronted him with the violent US interventions in South America and, via Israel, in Palestine. Claiming otherness was a fashionable social practice imported from the US, but which landed awkwardly in the mixed bag of Europeans that had sought out South London as their escape from this or that provincial outpost. It is a casual but flammable gesture that is not designed to be challenged, but since it relies on the assumption of a set hierarchy of structural violence, in culturally diverse contexts, often is.

Watch a room full of liberal arts students mobilize the sparse arsenal of weaponry garnered in their Introducing Theory course to weigh the wounds presented on both sides: the Colombian was factually of color, but her yelling at the American "you're Jewish!" was ringing Holocaust alarm bells. Both were from economically privileged backgrounds—an equal score. But the Colombian, made desperate by slick rhetoric and crowds roaring against her, dug her nails into his arm. For all its purported morality, identity politics will

14

justify using historical oppression to pepper any and every drunken drama, with a bloodthirsty audience playing as great a role as the warring parties. Under the spell of this magical departure from the post-politics of the aughts, the room prickled with excitement and a certain pleasure at the reintroduction of right and wrong. For the twenty-something years of our existence not much had seemed to matter, until now. The wheels of history were turning again, and each of our bodies had joined in the movement. The points were added up, and the verdict delivered: the young woman was clearly anti-Semitic. She was removed from the house on the back of an appropriately guilt-ridden straight man kind enough to offer his services to those less privileged, and dropped on the pavement outside.

A two-story Victorian terrace thumping Beyoncé remixes was a political battleground. I lived there, as drunk and scared in the trenches as the next person, poking my head out once in a while to take aim. In the production of a "safe space," no one was safe, it seemed, from being called into question, called out, or called upon to leave.

As "the 'illegitimate offspring' of liberal, capitalist, disciplinary discourses," Brown writes, "the psyche of the bastard child is hardly independent of its family of origin." I have much enjoyed being part of a community with zero tolerance for "Wonderwall" recitals—I'll admit it: revenge is sweet. But how sustainable is a politics based on revenge, or as Brown names it, following Nietzsche, *ressentiment?*

For Nietzsche, *ressentiment* has two expressions: "the moralizing revenge of the powerless," i.e., identity politics, and "the triumph of the weak as weak." The latter might describe what Achille Mbembe names "negative messianism," and would be the logic behind the political success of Donald Trump; the "will to kill, as opposed to the will to care." There are significant differences between these two, yet their shared complicated attachments to fear, safety, and victimhood are unnerving.

15

This comes back to the forceful non-distinction between subjective and collective pain fundamental to identity politics. In a loose application of Jürgen Habermas's concepts of "system" and "lifeworld," we might say that, in the London terrace, as in identity politics, the two have become thoroughly entangled. In this, we can recognize the second-wave feminist assertion that "the personal is political," or, as a sticker on the back of a friend's laptop read, "Depressed? It might be political." To my mind, the relevant question is not whether these statements are true, but in which particular contexts asserting their truth is most productive; when and how the personal wound is indeed political. In other words: between the blissful purity of the system we dreamed of as teenagers and the paranoid claustrophobia that ensues as system and lifeworld share the cramped space of a house party, there is a vast middle ground. Not a middle ground, necessarily, for compromise or consensus, but for feeling followed by thinking rather than reaction; for discussion, not exclusion.

*

In the summer of 2015, I started corresponding with a prison inmate in California named Michael. He was twenty-seven at the time, serving a twelve-year sentence for armed carjacking. While my reaching out had initially been motivated by interest alone, the letters quickly took on creative and intellectual value for me. A year later, our correspondence served as the framework of an essay I wrote as the culmination of my MA called "Doing Time," an edited version of which features as Chapter 2 of this book. The same problem as with the poster campaign applied, namely the moral implications of using someone else's struggle for art. But I was tired of the narrow shelter of the trench, firing from the safety of an unassailable position, and made this the whole point: I had to be doing something difficult and potentially wrong, in order for the project to somehow be right. This meant producing

a type of writing that would require commitment and effort and care to balance on a line with a responsibility not only to the text or the reader (or my vanity), but to Michael.

I structured the essay in four parts: Difference, Correspondence, Time, and Rehabilitation, in each part discussing our letters with reference to literature, philosophy, and film, as well as law texts and statistics concerning the prison-industrial complex. For me, it became instrumental as an intellectual experience in grounding cultural studies within a material and relational frame. Being able to reflect creatively and freely, while checking back in with life; does this actually make sense, is it actually true? "Sense" and "truth" suddenly reacquiring their meaning. This seemed like a way of setting boundaries for deconstruction, but without resorting to dogma. Being very specific about what I claim is true, rather than limiting the possibility or value of truth as such.

The project was conceived in order to conform to what I understood as an obligation to use-value, or societal relevance—an understanding of art and literature as forms of activism. At the same time, a combination of post-Chris Kraus frenzy and identity-political experience fetishism required there be a personal connection: a place from which to speak that was not intellectual but lived. This double commitment to the political and the private, though far from a contradiction within the scene, landed me in the troubled waters of appropriation. What did it mean to take on this topic, so distant from my own life? And to utilize my relationship with Michael in the process? Looking back, it is exactly this aspect that brings the text to life: that it is not the political martyrdom I thought I had designed, but something teetering on the edge of too-far, something actually very human. But once invigorated, "Doing Time" has not ceased being problematic for me, even years later. The second half of this book is an untangling of those problems.

*

Since leaving London for Berlin, some of my old militancy has gone. Not only because it had to in order for me to work in the commercial art world, but also out of respect for the difference between art and politics: out of a weariness of confusing one with the other. Previously, you might have caught me walking out of a Cy Twombly show, scoffing. Or not even looking at a lineup of Paul Thek paintings, short of registering their impotence in the face of structural violence. *Paul Thek!* Then you truly do not like art. Still, little more than a year later, I reviewed a show of monochrome paintings by the German artist Andreas Johnen for *Artforum*: "each hue emerges as its own strikingly haptic texture," I wrote, "an incredibly dense accumulation of time, labor, and material." Johnen applies one layer of pigment after another until the paper is completely saturated. That's when he knows it's finished.

The night Donald Trump won the US election, I was with my family in Leipzig. We'd stayed up the whole night in our hotel room, flicking between the channels, bottles of cheap *Sekt* bought out of the hatch of a petrol station undrunk. I had graduated from the RCA that summer, and our degree show opened on the same night as the Brexit vote. I hung out of a window above the courtyard as a drag performer triumphantly divided the crowds below like Moses did the Red Sea, an EU flag fluttering behind them as a cape. We woke up the next morning in the same state of disbelief as we did a few months later in Leipzig. I was never a fan of the EU (my teenage years taught me that it's capitalist and neo-colonial), and also keen to shift focus away from the US to other parts of the world. But such criticisms, it seemed, were immediately irrelevant. It was not *what* had happened, exactly, that felt so watershed, but the fact that it had happened at all: that places and systems we thought familiar had proven so volatile. That morning the already imposing

18

architecture of the Reichsgericht building looked especially ominous, its dome like the pointy helmet of a Prussian soldier. The whole city was foggy with *Weltschmerz* when I reached Jochen Hempel's gallery to find this in Andreas Johnen's works: comfort.

Comfort in that things can be simply what they are: that absolute depth and absolute finality exist: that with clean methodology, beauty will follow. That there is some kind of core of truth to things: an irrefutable foundation from which no decisions have to be made other than that initial one to saturate the canvas.

As political climates get harsher, the role of art changes in more than one way. "I don't know what to do about this," I wrote to Michael, referring to the emergence of fascism into the mainstream: "People like me should really pull themselves up by their bootstraps at times like these. And I will, soon."

But I didn't. Not exactly. The comfort that I had begun to find in art—in works like Johnen's that ask for formal readings—offered an escape from a political climate so heavy with *ressentiment* the middle ground had all but collapsed. This paradigm, which had seemed so exhilarating in its nascent state, and in our queer South London art bubble, it was now clear, did not ask for reflection and analysis, but merely for picking sides and joining the battle. Perhaps I was shell-shocked and hungover from Goldsmiths, perhaps just poor and in need of work—either way, I retreated.

That winter, "Doing Time" was partly published in a Swedish translation in two issues of the literary journal *Glänta*. The publisher invited me to talk about the project in Gothenburg, and that's when I wrote the lecture "Using People" (Chapter 3 of this book). Looking back, it was both part of my retreat and a rearmament. With "Using People," I rehearsed my defenses; I justified my belief in art as art, and since no one had actually asked me to, probably more to myself than anyone else.

After the lecture, Saskia Holmqvist, a teacher at the art academy who had brought her class along, remarked on the tightness of the composition, how stylized it was, how my reading of it was a performance. This was another watershed moment, a personal one, to go with Brexit and Trump and monochrome paintings. Watershed not in the tsunami-sense, instant and complete, but the beginning of a drip, which, in time, would change everything. As my need for money and comfort had caused my retreat from politics and enabled me to like art on its own terms again, Saskia's comment allowed me to appreciate my own work in that way too. To begin to recognize traits like style and structure as primal posed questions that had, strangely, never crossed my mind before, so preoccupied had I been with the ethical and political implications of the text: What is the status of "Doing Time" as a work of literature; not as testimony, but composition? To what extent have I written a piece of fiction, and what difference does it make?

The drip of fiction, or style, as it were, also asked me to acknowledge a motivation behind "Doing Time" that ran parallel to the sense of obligation to produce something politically "useful": the letters themselves, and my love affair, as Janet Malcolm calls it, with my own epistolary persona. I took so much pleasure in writing those letters—pleasure I had never quite allowed myself to take in writing before. Indulging in description, in metaphor, describing the people around me, and my emotions. "I wish you'd write letters like that to me," Chris said. Chris, who was everything to me in those days. There was passion in the letters, there was poetry, there was someone for the first time learning to love language not for what it communicates but for how it transforms the world. That rush of power, of control when you realize that you can conjure a version of reality just as you see it. That you can make a portrait so convincing it eclipses what is factually there.

My letter writing quickly grew compulsive, each one longer and more florid than the next. In Rostock you see

these massive cranes, I wrote, sitting on a FlixBus charting through northern Germany, shadows in thick gray air, not building anything or tearing it down, just moving it along, quietly. It was the same impulse that made me start writing about guys I'd go on dates with—the texts that became "Skin Hunger," the fourth chapter of this book. It picked up from "Using People" almost as if from inside it, testing the thesis I had proposed with each of its sections. The context was a lecture I had been invited to give at Biskops Arnö, a creative writing school north of Stockholm where *Glänta*'s Swedish translation of the first part of "Doing Time" had made it onto the curriculum. In both Chapter 3 and 4, the original settings of the lectures have caused some repetition, some filling in of blanks. Those texts are dotted with echoes, references like old friends popping back up, but at each reoccurrence asking to be considered anew.

What "Skin Hunger" also introduces, or rather what it teases out from between the lines of "Doing Time" and "Using People," is the theme of relationality, not just as a way of discussing responsibility, correspondence, solidarity, but things more deeply native to the lifeworld: togetherness, longing, vulnerability, and how those states relate to a writing practice. If, with "Doing Time," I integrated my subject (not only Michael, but the prison-industrial complex) into my own life in order to achieve, as feminist theory would have it, situatedness, or an embodied sense of objectivity, with "Skin Hunger" I took what came to me naturally and made it fit the mold of my imagination, turning whatever experience or emotional entanglement into a language object.

Sometimes a useful one, sometimes just beautiful. Useful in the sense that some stories became bigger than themselves, either as a form of art criticism, or because they spoke to some wider tendency, say, in neoliberalism or urban life. The more frivolous context of my post-Carrie Bradshaw life (post meaning in this case, to a great extent: poor) made it possible to isolate this component of the writing—the

spilling-over of myself—which had seemed too complicated, obscure, and even shameful in "Doing Time." Every writer gives themselves up in their work, just as perhaps they draw too much of the world into it. The relationship they have to their text and its topic is full of the same anxiety and confusion as a love story. There is so much narcissism there—falling in love with your own epistolary persona—just as there is in identity politics; a natural self-centeredness, as my pain (my story), or even my compassion for the other, performed as the annihilation of myself, is brought into focus. There's an honesty to "Skin Hunger," which in the context of this book I hope might bleed back into "Doing Time."

"Skin Hunger" posed another set of questions about what the effect of art and writing could be. No longer burdened with the expectation of political utility in my work as an art critic, writing had become relational in a way that, just as with Michael and "Doing Time," was not abstract, but at the same time not clouded by asymmetry or trailed by ethical conundrums. You always have a responsibility to the artist, to the gallery, to the magazine, it is never just you. It is often not clear whether an interaction is a studio visit, a date, or an exchange between friends. I'd sometimes joke that I thought everyone was flirting with me, when really they just wanted me to review their exhibition (the development of a Tragic Lover persona that was also only more or less "real"—notice that signifier starting to detach again). This also meant that the possible "violence" of a text was not a theoretical potential, but rather like an action, temporally limited and with concrete manageable consequences. Practicing transparency and owning any potential conflict had become part of the game. "Doing Time" presented a similar challenge of how to deal with a problem that never resolves, but in relation to which there is, nonetheless, love and energy and reason to keep going. The intellectual apparatus I'd taken with me from the Goldsmiths days, however, hadn't prepared me for conflict but for war—the point when there is no longer

any doubt as to where to draw the line of the disagreement. I only knew to join the powerless in moralizing revenge, to check my privilege and bow down, or to continue in what I'd been doing for the last few years, and retreat all together. With this book, I've come back to "Doing Time" with the art critic and date-chronicler's lived experience that conflict is not, as Sarah Schulman has pointed out, abuse—something that I was able to argue five years ago, yet did not quite dare to act out.

These days, things are different. That is to say, the conditions that apprehended me have not abated but exacerbated—the situation has become absurd. We have many ethical and political conflicts to engage with, yet public debate tends to linger on their cultural surfaces, getting stuck on simplified understandings of representation, and a radically essentialist relationship to language. When I wrote to Michael that "people like me'" ought to pull themselves up by their bootstraps at "times like these," the implication was to enlist myself in a kind of activistic mobilization of culture; what I had raised my glass to at the pub opposite Goldsmiths. I'd do anything, I'd be a Trojan horse, I said—as if the inside and outside of hegemony would be as clearly defined as the borders of an ancient city, or a prison. But in this escalated, increasingly polarized, and fearful context, what seems most important, for culture, at least, if not in other fields, is to maintain criticality and the courage to meet problems at their most complex.

The transparency that started with the men in "Skin Hunger" should have started with Michael, but couldn't have. The coming together of this book has not been a process of design but development; no one part could exist without the experience of having written the one that came before. Finally deciding to publish "Doing Time" in its entirety and, crucially, in English, pushed me to collect these thoughts and to understand how they'd evolved in the intervening years. Again, some basic impulse of literature played a

role—it lashed out from the page and made me get back in touch with Michael, not just to find resolution, but in order to achieve a narrative arc: to set limits, to reattach signifiers. I'm so grateful to language and its propensity for form and composition for not letting "Doing Time" and Michael remain a dangling clause in my past.

In "Love Lockdown," the final chapter of this book, I return to Michael and follow up on the questions I set out with: What are the boundaries of solidarity? What is the personal, relational price of sociopolitical asymmetry? How much can you possibly owe someone? Sometimes what is owed is seriousness, objectivity, detachment. That can be much less destructive, much more useful at length, than emotion, whether understood as erotics, excitement, or fear. At the same time personal investment is both a powerful engine and a poignant point of contact. You hurl yourself at love like into a dark lake, like a rowboat approaching a waterfall; a "hello" can flood the landscape, a metaphor can take over your life. In the end, Michael's and my correspondence, like any correspondence, perhaps, was so much more about what we've shared over the years than what we could ever owe the other in return. The love a writer feels at the outset might be for their own literary voice, their own sheer ability to elicit a response, but in that it so resembles the love of the other that the line begins to blur. The chapters in this book make an argument for the separation of life and art, art and politics, but together embody the impossibility of that very separation. This is a logic that takes contradiction for complexity in an effort to rescue from postmodernism its willingness to privilege richness over clarity, and what Robert Venturi termed "the difficult unity of inclusion, rather than the easy unity of exclusion." Almost a decade into my education in the "posts," I'm starting to feel certain that the endpoint of "anything goes" is not, finally, nothing at all—so long, at least, as you're prepared for a question to also constitute some kind of answer.

CHAPTER 2
Doing Time

DIFFERENCE

June, 2015

Dear Jonathan,

I am writing you from London, England. I am
trying to think through how I got the idea to
write someone who is in jail. I guess I have
been thinking a lot about America, and the
justice system. I don't know what to say about
it--I guess you know better than me.

 Anyway, I don't know what your situation
is--what you "did," specifically--but I am
sorry to hear that you are lonely. I am saying
"I guess" a lot, and "maybe." I am actually
a writer, or I am doing an MA in writing, so I
should stop repeating myself. But it reveals
what unfamiliar territory this is for me
to be treading. I can't imagine what your life
is like, I can't imagine what it is like to be
brown, or in jail, or live in California.
I can't even drive, so I couldn't have stolen
a car. If I could drive, maybe I would have.
But I thought perhaps there is something we
have in common. That perhaps you would enjoy
receiving a letter even from someone who
doesn't understand. Are you gay? I am. I don't
know if that means anything. Do you struggle?
What is the food like?

About a year ago I wrote this letter to Jonathan out of the
blue. I had found him on a website for inmates that want to
enter into correspondence. It looks like Facebook, except
the information is often outdated, and the links are often

29

dead. It's the shell of an online subject, or that subject twice removed—there might not be anyone at the other end, but I was lucky. I knew that Michael was gay, I chose him from the list of profiles because of it, and my sheepish unwillingness to "know" is completely uncharacteristic. If sexuality had presented itself as a way in, my motivation lay somewhere more distant from my own body. In the wake of Ferguson, Baltimore, the countless racist murders at the hands of police the year before, and the increasingly publicized racial bias of the US correctional system, I had read books, watched films, gone to demos—I wrote that I didn't understand, but there was nothing in my behavior, nothing in my often publicly expressed opinions to suggest such a modest respect for lived experience.

I now know that Jonathan is the name given to him by his estranged foster parents, and that he actually goes by Michael. I now know that Michael is not in jail, but in prison. In the United States jails are run by local authorities to accommodate those awaiting trial or on probation. Prisons are operated at state level or federally, and Michael is in his fifth year of a twelve-year sentence in a Californian prison for armed carjacking. I would say I now know to go slower, to take more time.

In middle school I had to write an essay about what I wanted to be when I grew up. I wanted to be a lawyer, I wrote, because I wanted to *help people*. Make a difference. I remember clearly the pressure I felt to be "good" in that way, to profess honorable intentions. The weight of morality was heavy on my shoulders as a child, morality and some idea of sincerity. The double-imperative of virtue *and* truth presented something of a conflict in this early essay of mine. The real reason I wanted to be a lawyer was that I wanted to be like Ally McBeal, a lawyer in a TV series at the turn of the millennium who wore Calvin Klein skirt suits and chunky heels. I couldn't bear to lie—I was too honest for righteousness—so I pasted in a pixilated image of Ally at the bottom of the page

in lieu of a confession. I saw straight through to the selfish heart of a Christian code and was even prepared to admit it. I probably knew about the money too.

In the last few years I have, nonetheless, begun to return to this idea: perhaps I should have been a lawyer. At least then I would have *known* something, what we are up against, for instance; I would have been able to *do* something. Instead, there I was, in the summer of 2015, tentatively putting into words why I was writing letters to a stranger in a Californian prison. In my first letter to Michael I passed on this career advice: you should consider law, it's good to know what you're up against.

The first few letters on my part are punctuated by hesitancy, a dutiful respect for the difference between us: that I *couldn't possibly* understand, or even with the moral implication that I *oughtn't*.

July:

> Meanwhile, I am working in an art gallery. We sit in a room full of MacBook Airs in minimalist outfits and talk about the migrant crisis.

And then:

> Do you feel this way too: that there is a big gap between us? I almost don't know what to tell you about my life.

The thing that you are truly confronted with when you begin writing letters is yourself as posture. Of her correspondence with a prisoner, the journalist Janet Malcolm, rather ruthlessly, writes:

> [I]f we are honest with ourselves we will acknowledge that the chief pleasure of the correspondence lies in its

31

responsive aspect rather than in its receptive one. It is with our own epistolary persona that we fall in love, rather than with that of our pen pal.[1]

My love in this case is fragile, and doesn't ever bear the trial of rereading. Instead, what emerges, like acne under fluorescent light, is that my respect for difference is not the same as respect for Michael—he had written nothing to warrant my pleas for reassurance—but is rather a way of excusing my own position, working through my own guilt. The awkwardness of asymmetry stands in the way of a love affair with my own epistolary persona.

What is more, my attempt at affirming difference within the letters is contrasted with my efforts to reduce it outside of them, even at the expense of my old principle of honesty. For instance, I would always lie about the gun. When I told my mom about Michael and his twelve years, the first thing she asked was what car it was, and then she said, *twelve years*, there must have been something else. Then, reluctantly, I mentioned that, well, *he was armed*.

Because he never meant to harm anyone anyway, because most of the time he did it it wasn't loaded, or it wasn't even a real gun, except the time he was caught it was, and now *twelve years*.

As I thought about it further, in a roundabout way, the gun, and even my lie about it, became a manifestation of my desire for closeness. I could write to him, like I did—"I can't drive but if I could, maybe I would have stolen a car too"—and then the gun could be that final point, that difference, both hard and arbitrary, which constitutes the space between us while also explaining it away. In other words, my lie about the gun identified a specific point of difference, and in doing so also identified the limits of that point: revealing sameness in its potential for removal.

My mom didn't ask any more questions, but when I confronted my friend Tank with the same logic she objected:

"It's so easy to get a gun in the US. If you admit that it could also have been you jacking a car, you may as well admit you would probably have had a gun too." Between the absolute difference performed in my letters and the desire for sameness I mobilized alongside them as justification, I was caught between two conflicting understandings of the self-other relation. In my mind, Michael and I were as in the philosophy of Emmanuel Levinas, for whom the other is so intrinsic to the self that the persecution of the other becomes the persecution of the self. Levinas refers to this relation to alterity as "breathless."[2] So although our relation is asymmetrical, Michael and I could be something like one and the same:
I could have jacked a car,
I could have owned a gun,
I could be in prison right now.

But in their guilt-tripping hesitation, the letters read differently. Not breathless, but rather Nietzschean, actually, in the sense that ethics became "bad air": so thoroughly polluted by my overwhelming ability to determine the conditions of our relation that we would not be able to breathe at all.[3] A kind of difference that is not constituted continuously within a single subject, but by the hard line between *inside* and *outside*. Between these two understandings of otherness, the nature of difference, not to mention its relationship to something like solidarity, to politics, seems crumpled and abysmal. That I *could* be in prison right now is not important, what is important is: I'm not, the ground beneath me is solid, and a gun is a gun is a gun—you either have it or you don't.
"Or what?" one might ask, as in,
is that really true, or:
and then what?

<center>*</center>

There are two sides to prison in California
General Population (GP): Mainline and

<center>33</center>

SNY (Sensitive Needs), which means that
it's basically protective custody.
I was on the Mainline GP for about a year.
That side is crazy. I'm Mexican & on top of
that from Southern California Sureño,
Southsider LA, so we have enemies: the Blacks
& Northern Hispanics. The southern Mexicans
are a unit with militant strict rules,
mandatory workout every day, & if the shot
caller tells you to do something, no matter
what it is, you do it, or else--well,
I'm sure you can imagine. The Blacks fight
with each other, Bloods and Crips, but they
riot as a unit. Southsiders are southern
Hispanic inmates from cities all over southern
California. Whatever beef the Mexican gang
members have with each other in the street
no longer is relevant and the rules are to be
united. I quickly went to protective custody
because #1 I'm not a gang member, and #2 I
didn't want to be forced to stab anybody.

This is from the first letter I received from Michael, hand-
written on yellow note paper. Like my own first letter, looking
back, is not very characteristic of him either. It's rather like
he's playing a part—*give the white boy what he wants*—each
component of the story runs into the next like gunfire, a line
of bullets with no punctuation, just the space of the fraction
of a second. The effect was me sitting there at the other end
with my mouth open—the expectation of surprise and its ful-
filment. *We're so different, this is crazy.* But that is the point,
right, so we carry on. From the MacBooked concrete floor of
my unpaid summer internship, I wrote to Michael again:

I am organizing a symposium of lectures at
the art gallery about the possibility of

34

solidarity. Like, is it possible for someone
in Sweden to be in solidarity with people
suffering in a conflict somewhere else?
Even though those people don't know anything
about each other's lives, and the "favor"--
if that is what it is--could never be returned.
What do you think? Can you and I be mutually
in solidarity with one another from across
the world?

Michael rephrased my question:

Can someone be in unison with another person
who is far away? I think if two people are able
to *depict* their experiences in their lives to
each other in a skillful way, enough to keep
each other intrigued, then yes, emphatically.

The shift from solidarity to unison is a shift toward same-
ness: it hinges on solidarity as a kind of identification. It also
brings us closer to the idea of the unit: *they riot as a unit.* In
prison, an emergency or crisis forces people to overcome dif-
ference and find unison at knifepoint. What is it that brings
Michael and I together, what would it mean for us to over-
come difference?

There are two sides to prison in California, Michael
wrote. It's ambivalent, folded in half—has ambivalent
potentials. Let's say there are two types of difference, two
ways in which difference constitutes identity. The French
philosopher Jacques Derrida writes *under erasure*, that is,
continues to use a word although it is inadequate, to strike
through it because it is inadequate and let it sit there. For
instance, to say "~~difference~~" is to say "difference is not," or
it isn't anything in and of itself—*it can't be.*[4] I think that is
probably true of difference: that it is. In his doctoral the-
sis *Difference & Repetition* from 1968, another philosopher,

Gilles Deleuze, refers to difference as "a reflexive concept," a passage, like a stream, between one thing and another or a thing and its name.[5] The assumption is that the stream flows organically, and that the difference between two things is informed continuously and freely. That is, you cannot distinguish any one part of the stream from another because it is moving. Until it isn't any longer, right? Maybe because of what Louis Althusser calls "interpellation"; a greeting, or a policeman's hail: "Hey you!"

That is: What are you doing here? Do you have papers?

Water gathers into a pool.

A subject at once emerges and drowns; stops breathing.

(Bad air).

This is the ambivalence: there's recognition, but it's suffocating.

There are subjects for whom emergence is a negotiation—a question: "Who's there?" "It's me"—for whom difference continues to flow. And then there are others whose breath is arrested and for whom difference becomes a knot in their throat, a stamp in their passport, a strike on their criminal record: Hey you![6]

This is the way in which an arrest constitutes a crisis, and it is crisis that activates difference.

It seems that this moment has an agent, an instigator, the authority that greets you, a hello that floods the landscape.

Crisis comes from the Greek *Krisis*, which means both judgment and "to separate."[7] It is easy to think of the encounter with the prison-industrial complex (PIC)—an encounter with law—as precisely this: divide, arrest, flood. Even the subject, Althusser writes, is a legal category before anything else: a subject of the law.[8] The prison-industrial complex is like a country within a country, disparate yet integrated, with distinct border crossings and other zones, calmer ones, further inland. The Mainline GP is for drug dealers and carjackers and gang members. The real psychopaths, Michael

says, are in the Sensitive Needs Yard. The Mainline is closer to the borders of the PIC, and as always, it is here that difference clots and the terms of its constitution are determined most rigidly. Clots to prevent blood from flowing. The rules are to be united, to stab or be stabbed.

The procedure is: arrest, jail, trial, reception center, prison. Identification, some level of assessment of difference, occurs at each of these stages. At trial the assessment is of the threat the inmate poses to the outside translated into months and years; within facilities it functions in part to protect the inmate, in part to ensure stability.

The first point of assessment is the county jail. In the infamously violent Mainline of the world's largest men's jail, the Los Angeles County jail, a special unit called K6G has been established in order to protect gay and transgender inmates, who are disproportionately victims of rape and harassment. K6G grants protection to vulnerable inmates provided they prove to prison staff that they are really eligible. To be "really" gay, for instance, inmates must have come out to their families, must provide testimonies, and even be able to identify certain venues in LA's predominantly white and affluent gay neighborhood.[9] For those who apply to K6G, this constitutes another type of arrest—another clotting of the flow of difference. For those who need protection, but don't apply, say because they're not willing to come out to their family, or have not lived a gay lifestyle, the alternative, most likely, is real, bodily violence. K6G says: there is only one type of vulnerability, and there is only one way to embody it. If your difference isn't legible on these terms, you stay in Mainline.

In the courtroom, Michael's sentence was pieced together in accordance with a series of catchy slogans starting with "Tough On Crime": under California law, carjacking itself will give you up to nine years in prison, depending on the circumstances. In addition to this, it is among the felonies that come under the "Three Strikes and You're Out" legislation,

which means firstly that a third such offense warrants a life sentence, and secondly that you must serve at least 85% of any one sentence before you are eligible for parole. Because Michael was armed he also comes under "Use a Gun and You're Done," which subjects you to ten years in prison for using a gun as a prop, twenty years for firing a gun, and twenty-five years to life for killing or seriously injuring another person with a gun.[10] In Michael's case, this all adds up to twelve years, and identifies him along some pretty hard lines: in or out, gun or no gun, done or not *as* done.

At prison reception centers inmates can stay for up to a hundred and twenty days, held in suspension, before their identity is assembled from a list of criteria and ticked or unticked boxes, and they are finally placed. Here, racial affiliation has long been the one primary criterion when assigning inmates cells: blacks with blacks, Southsiders with Southsiders. One-dimensional identity. A lawsuit begun in the 1990s deemed the practice discriminatory, and since 2008 California has started implementing what is known as the Integrated Housing Policy, not just at reception centers but across its prison system. This policy gives each inmate the option to "integrate" their cell, i.e., share with an inmate of a different race, but it has proven highly problematic. Many prisoners are reluctant to take part in the program, not just for fear of other races, but for fear of their own, of breaking the line between difference and sameness that constitutes identity. Michael wrote: "The shot caller tells you to do something and you do it no matter what, or else, well, I'm sure you can imagine." When officials at Sierra Conservation Center announced plans to begin integrating their Mainline, eighteen hundred inmates of all races voiced their disapproval by refusing to work or eat in the dining hall for three days.[11] This illustrates that while we would like crisis to have a known instigator, the production and arrest of difference itself is much more *integrated* than that, like Stockholm Syndrome or class treachery, not a simple matter of victim and perpetrator.

The prison where Michael is based is one of the first in California to begin to integrate its cells. In 2005, it became the only wholly SNY facility in the state, and perhaps for this reason it also became a testing ground for Integrated Housing. "These inmates tend to be more obedient," it says in a report from the *Berkeley Journal of Criminal Law,* "because disciplinary infractions can cause them to lose their protective housing."[12] Michael says this too, that once you've transferred to SNY "you can never go back to Mainline because you will 100% be stabbed." Sensitivity means vulnerability means vulnerability taken advantage of. You may hide in a ticked box to protect yourself, but once you do, you have nothing to bargain with, only something to lose. In other words: integration, like racial difference in Mainline, at knifepoint.

The assessment of Integrated Housing as an idea is profoundly ambiguous, and so are its results in other states that have implemented the policy. Segregation is bad, Rosa Parks taught us, in one of those scenes of history that have translated into universal ethics. But it is worth thinking about the distinction Martin Luther King makes between *desegregation*—the elimination of legal and social prohibitions that deny black people "equal access to schools, parks, restaurants and the like"—and *integration*—"the positive acceptance of desegregation and the welcomed participation of [black people] in the total range of human activities."[13] In bridging difference there is both the legal aspect of desegregation, say, Integrated Housing as policy, and the social one of integration, that is "welcomed participation." This latter aspect has two stages: white people welcoming people of color (and the conditions of this welcome), and people of color accepting the invitation (based on the conditions). It is a question of whether identification is a process of mutual recognition—this thing: *flow*—or a crisis, a judgment, someone else's definition.

In *Black Skin, White Masks* Frantz Fanon writes: "The white man, in the capacity of master, said to the Negro,

39

'From now on you are free.'" But doing so was a pronounce-ment on black people, not a mutual recognition; not a lib-eration from having to be constituted on the premises of another, but another ethical relation that turns, according to Fanon, the black man back on himself.[14] Seventy-seven percent of male prisoners in California are non-white. Forty-two percent are Latino. Even in a social environment so pre-dominantly non-white, the difference intended to be over-come by the Integrated Housing Policy is a difference defined in relation to white hegemony, not one emerged out of mutual recognition of people of color. That this element of racism cannot be overcome within the penal system is no great sur-prise. What is worse is that it does not even present a prob-lem for that system, but is rather the reason for its success as industrial complex. Both before and after incarceration, the fear and division that it wreaks are great leverage. It fol-lows that the safety of the prisoner is not the aim of the facil-ity but a bargaining tool to be used against them.

Finally, after county jail and the reception center, come prisons: the point when you are no longer on your way in. Here, the Prison Rape Elimination Act asks that facilities consider a much more comprehensive list of differences when housing their inmates:

> mental or physical disability, young age, slight build, first incarceration in prison or jail, nonviolent history, prior convictions for sex offences against an adult or child, sexual orientation of gay or bisexual, gender noncon-formance (e.g., transgender or intersex identity), prior sexual victimization, and the inmate's own perception of vulnerability.[15]

This list makes a detailed map to help institutions recognize all the bodies in the landscape. A whole range of differences adds up to this:

Sensitive Needs.

40

"All you do is you tell one of the correctional officers you don't want to be part of the Mainline politics and they take you to a committee and make you SNY." That's Michael. This sounds easy enough, yet at a different point he was in danger of being moved to a prison with no SNY and no college program. "Remember when I told you I was being transferred to High Desert. Well, let's just say that for some strange reason I started having mental health issues and ended up staying here." Although, from the outside, SNY's blanket diagnosis of vulnerability seems to violate the nuance of anyone's identity, it is also the only way for inmates to obtain safety, and what is more, its very generality allows for a kind of secret, private identity: grottoes behind waterfalls like "mental illness." This ambivalence might be the only source of potential in a landscape otherwise sapped dry, potential not exactly for subversion or resistance, but rather for producing any agency at all within incarceration.

Difference functions so differently on the inside. Identity is made out of objects like small stature and murder, tattoos and signet rings and the zip code where you grew up. Markers aren't fluid, the lines are drawn up hard: blacks with blacks, Southsiders with Southsiders. But the fact of the hard line is also what allows you to cross it, when something becomes an object you can trade it. The hard line draws a box for you to tick. By declaring yourself "sensitive," you move further away from the street laws of Los Angeles; by declaring yourself incapacitated, of poor mental health, you might enforce the break with the outside, the violence of which has only exacerbated on the Mainline, and protect yourself from it. For instance, on the topic of homosexuality, Michael says that, while on the Mainline it's "Hardcore, Militant, Gangbangin', No Fags Allowed," in SNY there is "an abundance of gayness." "Inmates fall in love with each other and cell up with each other." The Sensitive Needs Yard sounds like a gay vacation spot, but

41

with less pampered pets, probably the same amount of drugs, and more knives. It can be a bad thing, he says—there are a lot of miserable people: stalkers, predators—but it also constitutes a type of liberation. "A lot of people turn into Queens to compensate [for the lack of women]. Maybe they feel like they always wanted to be female and now in prison they could finally spread their wings, if you will." Isn't this a kind of break? Surprisingly, a break from the outside, as if the straitjacket that holds identities imprisoned loosens this far inland.

If one imagines difference as a reflexive concept, this flowing thing ruptured by crisis—the meeting with the prison-industrial complex and its list of finite identities for instance—is SNY a point where the flow picks back up? Not really. It is not so much a retracing of steps that leads one back outside, as a matter being so far inside that you cannot see the borders. Not just because violence persists in spite of SNY concessions and wing-spreading, but also because incarceration does not start with the prison. The construction of the outside relies on the general idea that there is fairness to the way difference is distributed and meaning is produced: the liberal fantasy that it happens on a level playing field. In fact, this idea of difference as flow is completely philosophical, that is, even on the outside difference is not constituted continuously, but according to an often static template. Trans people, for instance, will not be surprised by the demand for evidence at K6G—they probably have it all printed out and stapled together from their encounter with the medical establishment. Races are segregated in big cities completely automatically, as are sexualities in nightlife and classes on the high street. We discipline ourselves anyway. *Krisis* means judgment. And like the law functions as a deterrent, the constant expectation of crisis causes difference to clot even under the appearance of freedom. We might say "~~freedom~~" or "~~the outside~~," with Derrida, under erasure, because these concepts are *not* in

and of themselves, but only because incarceration *is*, and the inside is, too; because crisis also means separation: a hard line.

This confusion played out as I sat there in the art gallery, talking about the refugee crisis—*too rich, isn't it,* I wrote. While politely acknowledging my privilege, our absolute difference, in the letters, I enacted my own exacerbation-into-total-sameness alongside them:
I could have stolen a car, etc.
—I could be you.

While for Michael negotiating difference meant navigating ambivalence (loophole grottoes and hiding places; identification always with a dramatic caveat), on the outside I was juggling a binary: we are either different or we're the same. What I failed to understand was that the difference between us, whether real or essentially relative, is not such a generative place to dwell. And Michael never joined me in my frantic emphasis either. Instead, he looked for points of entry: `"I'm so proud of you, doing your MA, it must be hard when you don't have a lot of money."` Or: `"I just received your letter (by the way, very well written as always)."`

I had all sorts of ideas about my overwrought writing style; "the way in which," semi-colon, italics. *Unbearable.* Every time I was writing from a new place, an (Easy-)Jetsetter. *Offensive,* I thought, in hindsight. But ornament in language as elsewhere is an invitation for flattery, and flattery only a hop and a skip from flirtation. Why would we be corresponding if not to ingratiate ourselves? Michael wrote:

> `It really struck me the way you were able`
> `to depict to me the imagery of Denmark,`
> `Berlin, and Venice … you give me insight on`
> `what it's like to live where you live,`
> `it's really amazing.`

He had used the word "depict" before, on the question of whether two people in very different situations could be in solidarity, or what he called "unison": "I think if two people are able to *depict* their experiences in their lives to each other in a skillful way … then yes, emphatically."

Another point: "I'm attracted to intelligence, it's sexy to me." Is this a glimpse of fluidity? A difference that isn't just power, not just defined by my white, educated, hegemonically recognized body that floods everything with the hard light of biopolitical hierarchy. *It's sexy to me*: okay. Maybe I needn't be so careful in observing difference; maybe my privilege isn't so alienating; maybe between us is a fold in the map from within which we can see the inside and outside for what they are, and the divide between them clearly as manufactured.

"Manufactured" is not to say that the divide, the difference, the judgment that has taken place is fake or insubstantial—on the contrary, some of the most stable and violent material realities around us are manufactured—but that it is political and made with barbed wire. It is also not that I *oughtn't* sympathize or understand for some moral reason, but that sympathy is inadequate material for the political anyway. For Sara Ahmed the recognition that difference cannot be overcome is the basis for collectivity. In *The Cultural Politics of Emotion* she writes:

> The impossibility of "fellow feeling" is itself the confirmation of injury. The call of such pain, as a pain that cannot be shared through empathy, is a call not just for an attentive hearing, but for a different kind of inhabitance. It is a call for action, and a demand for collective politics, as a politics based not on the possibility that we might be reconciled, but on learning to live with the impossibility of reconciliation, or learning that we live with and beside each other, and yet we are not as one.[16]

44

This is not a move toward a defeated compromise in which reconciliation has been abandoned, but a principal refusal of an end point, of a resolution that might relieve anyone of complicity or responsibility. It is to say: there is nothing to wait around for, there is only now. What exists between Michael and I is for that reason not an antagonistic irreconcilability, but one that stretches toward a political collectivity like a willingness to remain; to bear continuous witness to confrontation, and *not* to overcome difference. An inside that corresponds to the outside as the confirmation of an injury, inside and outside corresponding with one another.

CORRESPONDENCE

I have a question for you. Could you ever
fathom me and you meeting in person?
I would definitely be so excited. I feel a
connection with you because I feel like
I made a real friend…. So far I've had people
write to me but they don't keep in touch
longer than a few letters.

The first rule of having a prison pen pal is: don't make a promise you can't keep. Don't say you will send books if you're not going to; don't say that you will come for a visit if you can't. I was anxious not to break this rule. Could I "fathom" meeting Michael in person? I mean, he has another six years in prison, he lives in California, and what is more, what would we say to one another? Afraid of being confronted with the irreducible ground of our difference, sitting there and realizing that the gap is just too wide, I didn't respond to his question initially. But as I began to understand something about the hopeless agreements of prison life, about hope, in general—that on the inside you need it to get by, and that it is

not about "in six years" but about *right now*—I understood something also about the responsibilities of correspondence: to not be afraid of difference and *respond*. So finally, I did: "Yes, why not?"

The responsibility to respond is entangled with the idea of the promise. "To breed an animal with the prerogative to promise," Friedrich Nietzsche writes in *On the Genealogy of Morality*, "is that not precisely the paradoxical task which nature has set herself with regard to humankind?"[17] The entitlement to make promises is the basis of the free and ethical human being, and it requires that being to remember the promise under changing times and circumstances. "How do you give a memory to the animal, man?" Nietzsche asks. "How do you impress something upon this partly dull, partly idiotic, inattentive mind, this personification of forgetfulness, so that it will stick?" The response: "A thing must be burnt in so that it remains in the memory. Only something that continues *to hurt* stays in the memory."[18] In other words, the relation between those who are entitled to make promises and those who aren't—the ethical relation—is not only asymmetrical, it relies on a pain and violence that is both historical and continuous.

The rule that says "don't make a promise you can't keep" is a Nietzschean critique of ethics, which takes into consideration the power of one part of the relation to toy with the promise and redefine it. The ethical being is only amusing himself with the toy, Nietzsche would say. The rule of having a prison pen pal says: this is not a game. I want to use the idea of *correspondence* instead of, or together with, words like ~~solidarity~~ and ~~ethics~~ as a way of inserting responsibility into the Nietzschean paradigm anyway, to insist: this is not a game, and it is not just a theory either.

The principal definition of "correspondence" in the Oxford English Dictionary is this: "The action or fact of corresponding, or answering to each other in fitness or mutual adaptation; congruity, harmony, agreement."[19] To answer to

another, or even to have the duty of answering, *answerability*, points to the way in which responsibility and correspondence are intimately linked. But does that mean one can only ever be in agreement? Not responding to Michael's question is the worst thing I could have done, but what if I had said: "No." Surely that too qualifies as a response, requires a sense of responsibility?

This is a question of the difference between correspondence as agreement or exchange and as (co-)responsibility. Correspondence as sedative, comfort, hope, or as something more objective, political, *productive*. In between these two definitions of the word is a third one: correspondence as intercourse. This use is obsolete now, and historically it meant something much more general than what it implies today, but still, something is revealed about the relationship between ethics and erotics at the core of which is the potential for betrayal. The betrayal of language as it does not correspond to reality; the betrayal of the correspondent who falls in love with their own epistolary persona; the correspondent who fails to respond, or fails to respond appropriately.

On October 17, 1959, during what he described as "a time of need," the German poet Paul Celan wrote to his friend and onetime lover, the writer Ingeborg Bachmann. When he did not receive an answer he wrote, "equally in need," to her partner Max Frisch, who was also a writer.[20] Celan was convinced that Günther Blöcker's negative review of his poetry collection *Sprachgitter* in the German paper *Der Tagesspiegel* was motivated by anti-Semitism. "Hitlerism, Hitlerism, Hitlerism. The peaked caps," he wrote simply, yet somewhat opaquely, to Frisch.[21] He was asking his friends to respond, as they had before, to *correspond*; share responsibility for the injustice by acknowledging it—help him carry the burden. They would do this, Celan thought, first by responding to his letter, and perhaps after by supporting him publicly and responding in the papers. Frisch, although he had much less at stake in his relationship to

Celan than Bachmann, wrote four draft letters before finally sending a fifth one. "They are all no good. But I cannot leave you without an answer. But what on earth shall I write?" And he continued:

> You give me credit for not being an anti-
> Semite. Do you understand what I mean if I say
> this does not give me much leeway? …
> I am worried by the prospect of being reduced
> to a reliable anti-Nazi. Your letter, dear
> Paul Celan, does not ask me--your letter gives
> me a chance to prove myself if I react to
> the review by Blöcker in the same way as you …
> if there is the slightest hint of [vanity
> and injured ambition] in your anger, it seems
> to me that naming the death camps would be
> impermissible and egregious. Whom am I telling
> this! If you make a political phenomenon
> out of a review like Blöcker's, I think you are
> partly right but also partly wrong, and the
> one problem blurs the other. [22]

Bachmann herself did not respond until after Frisch had already sent his letter: "I could have prevented [Max's] letter from being sent, but I still think I did not have the right to do that, and so I simply have to endure these coming days in uncertainty." She did not have the right, but she also didn't entirely disagree with Frisch: "Is anti-Semitism the reason?" she wrote in the same letter, "I am not sure yet." [23] What plays out between them is a great ethical concern that strikes at the heart of what it means to correspond: to agree or to agree to respond. There is the question of truth—"I think you are partly right, but also partly wrong"—whether it has a place within the political, within solidarity. But there is also the question of leeway: the space left for the response of the other,

what it says about the symmetry of the relation whether one feels obliged to fill the shape of that space or not. Max Frisch did not want to be "reduced" by it, yet at the same time, historical circumstance might justify that Paul Celan did not ask for, but demanded agreement. That is the question, right? What happens to violence, historical, systemic, ongoing violence, when it meets the inevitable nuance of real individuals. "I am not sure yet," Bachmann wrote. I am not sure either.

Bachmann, Frisch, and Celan's correspondence becomes the home not of question and answer but of a continuous undecidability in relation to the difficult matter of how we distinguish between personal and collective responsibility: moral and ethical code. Chantal Mouffe writes that "deconstruction produces undecidability, which in order to be political, must provide positive grounding for decision." Within Mouffe's paradigm (and mine) deconstruction is a necessary starting point, and thus the paradox becomes a necessary consequence: the simultaneous presence of undecidability and decision—"something else is needed," she writes,[24] in order to make room for what Frisch referred to as at once "partly right, but also partly wrong." What that "something" is, I suppose, depends what we need the political for. What I am looking for is a framework within which solidarity can become political, that is, agonistic, positional, as well as ethical, and for one not to compromise the other. One might say the same of Bachmann and Frisch. They go to great lengths, suffer some pain, to negotiate the place of undecidability between them and Celan, not the same pain as his, but a different pain, an openness toward pain. Yet in spite of their labors, in the end, their correspondences collapsed. Celan was prone to depression, not well, and needed correspondence—friendship—to sedate and to comfort him. It is clear that Michael is the same. To the question of what *I* can do for *him* the answer would be just that: comfort. Yet there is the primary rule: do not promise anything you can't keep; there is the fact that the promise is mine to define to

begin with; there is the impossibility of reconciliation and the inevitability of betrayal.

And then there is "something else." The reason for Bachmann's commitment to truth is that she is emotionally invested in both Frisch and Celan, just as the potential that I lied to Michael in agreeing to meet him "in the streets" is motivated by the same. The streets, correspondence, the inside of a prison cell, all become, to an extent, hypothetical or symbolic spaces in which truth must be balanced by commitment—responsibility to a hyper-local context. This balancing act, and its limit, also plays out in the Argentine writer Manuel Puig's novel *The Kiss of the Spider Woman*. It is written entirely as dialogue between Molina and Valentin, cellmates in a Buenos Aires prison. "Here we are," Valentin says, "all alone, and when it comes to our relationship, how should I put it? We could make any damn thing out of it we want; our relationship isn't pressured by anyone."[25] Again this fold in the map, this break that makes room for some movement. Molina recounts films in great detail to pass the time between the two—not just to pass time, but to *ease* time—also between the stabbing pains of food poisoning they suffer in turn. For both Molina and for Valentin, the film summaries help take the edge off, help comfort—help them think of something else.

> —I swore I wouldn't tell you anymore films. Now I'll go to hell for breaking my word.
> —You don't know how it hurts. Like a terrible stabbing pain.
> —Just what happened to me the day before yesterday.
> —But they're getting stronger and stronger, Molina.
> —Well then you should go to the infirmary.
> —Don't be stupid, please. I already said no.
> —A little Seconal won't do you any harm.
> —Yes it will, you get habituated. You just don't know about it, so it's easy for you to talk.

—Okay, then I'll tell you a film ... But what don't I know about Seconal?[26]

What Molina doesn't know about Seconal, a brand of barbiturate commonly used as a sedative at the time, is that guards would get political prisoners such as Valentin deliberately hooked on it in order to weaken them: "until finally, when interrogated, we could be made to say anything ... Agh, aghhh ... See what I meant before ... the pains become so sharp ... as if they were punching holes in me ... it's like having nails hammered into my stomach."[27]

Valentin knows that storytelling, too, can sedate—that is the point. What he doesn't know is that its side effects might not be entirely benign either. Molina is a queer man—
Molina talks of himself in the third person feminine
 (so I will do the same)—
Molina is in for corrupting a minor, her mother is ill
Molina doesn't have much to bargain with if faced with an offer,
Molina might still be working for someone,
 might still corrupt Valentin,
too, be her own brand of Seconal—
Molina might make him say anything.

—Well, let me tell you the film, to distract you a little ... *take your mind off the pain.*[28]

They share their food and their stories are their Seconal, and when finally they also share a bed it is only the arbitrary bodily manifestation of an elaborate intersubjectivity generated between them over time and with betrayal at its center. What Valentin doesn't know about Molina is that in exchange for a pardon for her crimes, she has agreed to attempt to make Valentin confess to her the details of his political organization. To make Valentin trust her, and out of a still more desperate guilt, Molina becomes willing to do anything: she

51

inflicts food poisoning on herself by eating the bad food the guards have prepared for Valentin in order to break his resistance, she cleans up the outcome of Valentin's eventual diarrhea with her own sheets, shares the last of the guava paste, her favorite. Starting with Molina's betrayal and ensuing desperation, the boundaries between them dissolve until finally Valentin is actually inside her, on the cot:

> —Just then, without thinking, I put my hand up to my face, trying to find the mole.
> —What mole? … I have it, not you.
> —Mmm, I know. I put my hand to my forehead, to feel the mole that … I haven't got.
> —…
> —And you know what else I felt, Valentin? But only for a second, no more.
> —What? Talk to me, but just … don't move …
> —For just a second, it seemed like I wasn't here … not here or anywhere out there either…
> —…
> —It seemed as if I wasn't here at all … like it was you all alone.
> —…
> —Or like I wasn't me anymore. As if now, somehow … I were you.[29]

Betrayal and guilt become desire for the other person's forgiveness, desire for the other person—or perhaps it was all along. The endpoint of a certain mode of sexual desire, a certain but prevalent mode of falling in love, is non-existence; to disappear into the other, disappear from context and geography into flowers, into smoke. Disappearance: Is this the logic of correspondence as intercourse? In his novel *The Thief's Journal* Jean Genet declares: "there is a close relationship between flowers and convicts."[30] Writing from within prison, Genet has no obligation to truth, in fact he has an interest in

un-truth, like Molina and Valentin, in non-existence. In his short film *Un Chant d'Amour* from 1950, prisoners are vessels for the sensual exchange of smoke through a straw. At that point, for Genet, that is what correspondence is about: the sheer matter of desire. Closely adjacent to falling in love with your own epistolary persona is collapsing the distinction not only between the correspondents, but between agents of desire and desire itself.

Because desire is a great fuel, prisoner correspondence abounds with eroticism. That's why you can filter inmates by sexuality on prisoninmates.com, that's how I found Michael, that's why many users upload sexually charged profile pictures. I introduced sexuality in my first letter, and Michael from the onset would describe himself as "fairly attractive" and for that reason vulnerable to "predators." "You're sexy," he also said, "sorry I had to tell you what's real." And then: "tell me about your sexual encounters," and then, "could you send me a pic with you in your briefs and a naked pic (only backside butt they will allow) sorry if I'm being too direct just bored and curious." Afraid of breaking the promise, afraid of betrayal, again, I delayed my response. But eventually I wrote:

> You ask me not to be offended, to tell you
> about my sexual encounters. "I'm just curious …
> I want something to think about," you wrote.
> I guess I am offended--or not offended, how
> could anyone be--but feel as if something has
> been lost of what I am trying to achieve
> with you … Still, I would be lying if I said
> there wasn't an element of sex driving our
> relation on my part too. So--trying not
> to lie--what is it that apprehends, if not
> offends, me, anyway?

In his letter, Michael had mentioned my "essay"—this one—which I hadn't actually come up with at the time, and so couldn't have raised. In a way, he knew before I did that the letters would pull me in and demand more writing. But even the suggestion that I had approached him as a "project" tickled some nascent hang-up in me, the question of ethics that would come to mean so much to the essay I had not yet decided to write. I continued:

> Although I didn't approach you as a "research topic," my academic or writerly interests are so intertwined with my personal life that there is no telling whether maybe I am "using you" for research, *what am I using you for*, I ask myself. I am getting something from you: your perspective. What are you getting from me? "Something to think about." Alright. And again, your picture is cute: *I would be lying if I said* … Sex is already there, isn't it, in all of it, my research, my personal life, whatever. So what do you want to know?

I was the one who wanted to correspond, so here's the deal: respond—don't try to redefine the promise. But outside of this knee-jerk and naive sense of obligation to Michael, my uncertainty about a turn toward eroticism in our correspondence lingered as what I'd explain as a fear of ejaculation:

> You know how after you come, you suddenly feel very different, very silly--the thing that mattered just before, now belongs to a different mindset entirely. I don't want our conversation to depend on the whims of desire in that way, or at least to ejaculate prematurely.

There is a definite limit to the potential of the erotic as that "something else" that enables the paradox, perhaps like fuel without engine, or in perpetually short supply. Michael shared this concern: "You're right … I don't like receiving letters from people that are strictly sex-oriented; that's really disappointing to me." Remember, "so far I've had people write to me but they don't keep in touch longer than a few letters." As love is threatened by betrayal, so desire is always in danger of being annihilated by fulfilment.

Between Genet's works of the 1940s and 50s and his final novel *Prisoner of Love* first published in 1986, something changed, something like a shift from erotics to ethics. For one thing, Genet was no longer in prison. His need for the erotic dissolved. He began to refuse sedatives both literally and metaphorically. By the early 1980s, he was suffering from throat cancer but endured the pain in order to remain lucid while writing. Time was running out, and while Genet had not published literature for several decades, he knew he had the responsibility of a final work resting on his shoulders. *Prisoner of Love* is a fragmentary text about the struggle of the Palestinians as Genet himself experienced it through his involvement with the cause since 1970. The truth it aspired to would have got lost in the fogs of anesthesia. It required the absolute brightness and clarity of pain. Although Genet's involvement with the Palestinian struggle was rigorous and uncompromising, what he was able to give was always marked by the remove implied by solidarity: not you, not without a country, not your home, in the end. "So did I fail to understand the Palestinian revolution?" he asks in the opening pages of the book, "Yes, completely."[31] Writing without sedatives became a matter of *leaving something there*, at the point of struggle, *anyway*. A matter of measuring one's distance, of failing to understand, yet continuing to write—the shift from prisoner to ally requires this paradox.

The writer and philosopher Simon Critchley writes about Genet's difficult last work that it is a novel about the possibility of telling the truth that reads like slides projected without captions. "Can writing tell the truth?" He asks, "Or must writing always exist within an economy of betrayal?"[32] In *Prisoner of Love* desire also plays a part, but a different, more sustainable one:

> Also present was the very subtle but very strong eroticism. It was so strong, so evident yet so discreet, that while I never desired any particular person, I was all desire for the group as a whole. But my desire was satisfied by their existence.[33]

How is this possible? A desire that rests within itself, that is not directed toward any object in particular. Critchley points out that while Genet would normally be seen as the ultimate enemy of Hegelian European *Sittlichkeit*, paradoxically the truth of *Prisoner of Love* is the postulation of a Palestinian *Sittlichkeit*, "a form of political truth"[34]—desire without ejaculation. *Sittlichkeit* means morality, a specifically bourgeois morality, but is related to *sitten*, which means to sit, the physical rootedness of bodies in a landscape (or the Biedermeier living room)—the stable signification of things. I want to continue using this word, not for Hegel or for Europe or bourgeois morality, but for *the seat*, because Michael and I need one to write from, however paradoxical.

In an essay called "Using People: Kant with Winnicott," Barbara Johnson uses the child psychologist D. W. Winnicott's theory of the transitional object of a young child to outline a subject-object relation that is not only exploitative. She thinks of the transitional object "not as object but rather as use of an object, as paradox, allowing it to remain paradox," and argues that:

the properly used object is one that survives destruction ... object-relating is contrasted with object-use in that object-use involves trust that separation can occur without damage ... perhaps a synonym for "using people" would be, paradoxically, "trusting people," creating a space of play and risk that does not depend on maintaining intactness and separation.[35]

She takes from Winnicott the image of the philosopher in his armchair: "the intellectualizer-away of the paradox: the object is either inside or outside, destroyed or not destroyed." If the philosopher got out of his chair, Winnicott says, and took a seat on the floor with his patient, he might see that this is not necessarily the case. There is an intermediate position in which the statement "the object is destroyed" can be followed by "the object survives"—on the floor, *engagement*.[36] If, within the framework of my text, child and object become *self* and *other*, and intactness and separation perhaps consensus and difference, Johnson's argument is one for going ahead and *using people*, assuming agency and trusting in the relation to survive betrayal.

In *The Kiss of the Spider Woman* betrayal comes before anything else, before the event of the story, but only disclosed to the reader after. Molina's deal with the guards becomes a primal scene from which all emotions and desire spill out—taking care of one another, easing time with one another, eventually making love to one another, and finally Molina the Spider Woman kisses Valentin and agrees to take his secret message to his comrades when she gets out of prison—all is an act of compensation, all is redemption from guilt, but it is also real love, plain and simple. With both the police and Valentin entangled in her web of amorous betrayal, Molina walks straight into a hail of bullets, like the heroine in a film, into death.

"There may or may not be survival," Winnicott adds. Sitting on the floor, too, is a dangerous game.

57

This kind of game—excessively dangerous—plays out in *Snitch,* a film from 2013 that Michael recommended to me as "a good depiction of modern day prison." Like Molina and Valentin, we've also exchanged films, and like the time Molina told Valentin about a Nazi propaganda film thinking it was a simple romantic drama, I must say: *Snitch* is unbearable. I'm sorry, Michael, now you know. Dwayne "The Rock" Johnson plays a father trying to get his (strangely) white, middle-class, on-the-way-to-college son out of a ten-year minimum sentence for drug trade by acting as a snitch to a conservative candidate for congress. Rather than deconstruct any of the assumptions that underlie the penal logic, the film transforms the snitch from traitor to hero in the name of redemption for a betrayal that happens off screen: Johnson's character has failed as a father, and this is his chance to prove himself. But here the film breaks. *Snitch* is not a portrait of a tormented parent but a series of car chases and explosions; a portrait of an Action Man with a nickname to live up to—"The Rock"—high on testosterone and the wet dream of the Ethical Being. In the end, the prison-industrial complex is left unscathed and largely uncriticized as Johnson's son is released from prison, and, along with the rest of the family, disappears into a witness protection program. Bad air indeed.

Yet read against the grain like this, *Snitch* and its portrayal of a desperate masculinity in search of redemption also hits a little too close to home. My home. In a way, The Rock is not so different from Molina, the queer so desperate to be loved by "a real man" she'll do almost anything, except the object of The Rock's desire is not to disappear into another person, but precisely to emerge and be recognized as the ultimate subject himself. Betrayal is an engine here, but with such selfish ends it jeopardizes everyone involved. Sitting on the floor means taking a risk—it's a minefield—but a risk taken least of all on one's own behalf.

In prison correspondence one implication of that gamble is that nothing is private. "Mail going into prisons is

screened and read more frequently than mail coming out of prisons," the pen pal guidelines of the Bent Bars Project advises. "Don't assume that just because your pen pal disclosed personal information in their letter that it's alright to discuss it freely from then on."[37] The letters are intercepted, and mine more so than Michael's. Like the Bent Bars Project, Black & Pink is an organization that helps facilitate correspondence with queer inmates. On their website they write:

> Mail Call often happens in public spaces in the prison. When someone hears their name called by a prison guard during mail call it is a reminder that people on the outside care about that person. It is also a message to the guards and other prisoners that this person has support and is not forgotten. This can be a vital harm reduction strategy for people who are locked up, especially queer and transgender folks.[38]

Here we might think again about the ambivalence of Althusser's interpellation theory. When Michael receives mail, he is recognized as a subject not just on the terms of an authority—Hey you!—or by the gaze of mutual recognition between prisoners, *as* a prisoner, but by *someone else* whose mode of address he has taken part in constructing himself. Michael, not Jonathan, for instance, not his last name, not his ID number. But what does it mean to discuss openly someone's sexuality, or their gender, or their drug abuse in a letter that might be read by someone else? (Much less in an essay available to a still wider public.) Interpellation is also a process through which a subject becomes visible. It is not hard to imagine that in prison, sometimes you're better off not being seen.

When I asked for advice from Black & Pink they replied, unlike Bent Bars, that since Michael is the one taking the risk in bringing up these questions to begin with, I should follow his lead. Is that true? That I have no part in the risk? I

59

suppose so, simply because I will never see the consequences. That's the difference between us: irreconcilable. So what is the difference between me and The Rock?

This comes back to the agency implied by the different interpellations that constitute our respective subjectivities. The Rock says "Hey you! I'll save you!" like the slave owner said to the slaves: "You are free!" and then redefined what freedom means in order to make that statement true. What would it mean to say, instead: "Who's there?" To start from not knowing: trusting Michael to survive rather than promising to save him. Both are ideological, there is no getting around that. "The ideological subject," Althusser says, is a "tautological proposition"—it's so obvious we don't notice.[39] But the obviousness—the invisibility—of ideology wanes as it becomes necessary to enforce. In prison, a more rounded subjectivity is contingent on precisely "obviousnesses" such as eating in the canteen, receiving letters and parcels, access to entertainment and the outside yard. These mundane activities become a privilege earned through work and good behavior. Therefore it is also in the realm of the obvious—small things, daily life—rather than through sweeping and heroic efforts, that the subject is healed; where one subject might recognize another in more than just a legal sense, not as a pronouncement on that subject, but as negotiation, conversation, correspondence.

In *The Kiss of the Spider Woman*, food and eating is as central to the intersubjectivity developed between Molina and Valentin as erotics. Molina gets food from the guards in return for her betrayal, packed just as her mom would have done it, to make it seem believable: two grilled chickens, four baked apples, guava paste. Valentin eats most of it. Today, in order to send parcels to inmates, you must go through facility-approved vendors such as Golden State Care Packages. A "Basic Edition" care package from Golden State costs $49.99 and most notably contains eighteen packets of instant ramen noodle soup.

We may not like the same films,
but here,
let's eat, anyway.

This *anyway* is the paradox—the continuous existence of contradictory elements alongside one another; the survival of Winnicott's transitory object, undecidability and decision. The *anyway* of Genet, who "is committed to telling the truth even when he knows that the truth cannot be told";[40] Genet failed to understand the Palestinian revolution:

> I think I realized when Leila asked me to go to the West Bank. I refused, because the occupied territories were only a play acted out second by second by occupier and occupied. The reality lay in involvement, fertile in love and hate; in people's daily lives; in silence, like translucency, punctuated by words and phrases.[41]

In other words: *in between things* like packets of ramen noodle soup, daily life, the seat on the floor, in the sustained-ness of a commitment—a temporal aspect. On the final page of *Prisoner of Love*, Genet writes that what remains with him from the revolution is the image of a mother and son in the little house where he slept for one night, and fourteen subsequent years during which he tried to recall if that night ever happened. In acknowledging the failure of memory, Genet also acknowledges the failures of ethics, as Nietzsche defined it: to have always-already failed to remember the promise. This dreamlike image, almost nothing, is as close as Genet gets to a truth about the Palestinian revolution. It's a redemptive moment—the point of transcendence from betrayal—that happens when he is given a glass of water and a cup of coffee by the mother who mistakes him for her son. At that moment, Simon Critchley writes, through coffee and water, Genet is provided with a mother, a home; "at that moment Genet achieves a breakthrough into the reality of involvement, fertile in love and hate; in people's daily lives."[42]

This is his *Sittlichkeit*: a seat from which he looks back and sees only the failure to represent, to be true, but *sees* nonetheless: writes *anyway*. Or like Bachmann and Frisch wrote to Celan, enduring "days of uncertainty," four torn up letters, "they are all no good. But I cannot leave you without an answer."[43]

The only promise I can make,
the only obviousness I can offer,
is that—beyond myself (my writing) and beyond difference—I will continue to correspond.

TIME

"So was there a tide in the laguna where you camped," Chris asked. "I don't know," I said, "maybe there isn't a tide on the west coast." "What do mean there isn't a tide," he retorted, "the moon is everywhere."

Tidal forces are big waves generated by the sun and the moon that travel around the oceans. Their travel time depends on a series of factors like coast orientation, continental shelf margin, water body dimension—because of this there can be a time-lapse between the phases of the moon and their effect on the tide. The time it takes for the wave to reach a given shore is called "timing," the length of the potential lapse is called the tide's "age."

Can we imagine a country within a country within which there is no tide? That is, a country without sun and moon, or one, at least, within which the potential time-lapse of the tide—these inconsistencies caused by certain factors—is not inconsistent but in fact consistent, not incidental but designed. Can we imagine a view to an ocean *consistently* without waves?

When on January 1 I was camping on the laguna on the coast of Chile, I had not given any thought to whether there

was a tide. But the "country within a country"—the prison-industrial complex—how time stands still there, *that* idea, and my view of it, was becoming more and more real. Time between Michael and I, as our maps were integrated into one another, became stunted. Like he lived in a fold and I approached it like a rowboat approaching a waterfall. Like there were obstacles or certain conditions—coast orientation, continental shelf margin, water body dimension—that thickened time between us, that aged our tide.

I sent a picture of the laguna to Michael in lieu of a postcard.

I sent it via a service called Jmail that allows you to e-mail your letters to a Los Angeles postbox you pay a yearly fee for. They then print out the letter along with any pictures—you can attach directly from Instagram—and send it by post to the prison. Jmail lets you see when it was printed, usually the next day. When Michael replies it is with hand-written letters sent to the postbox, then scanned and e-mailed back through Jmail. I pay both to send and to receive. He usually begins his letters by saying "yesterday I received a letter from you," or "this morning." He also usually dates his letters, so even if they aren't sent the same day, I can still work out exactly how many days it has taken for my letter to get from Jmail to his cell. Usually between seven and ten, a couple of times as little as five, a few times more than thirty. The first time that happened was around the time of his birthday in August, and I wrote him another short letter asking him just to let me know he was OK. By the time it arrived it made Michael think I hadn't received his eventual reply to my original letter, causing him to write another one in response. Our correspondence became tangled with itself, time-lagged responses to different letter threads arriving together or too far apart.

In the months leading up to Christmas it was as if time had come to a halt completely. By early December I hadn't heard from Michael for almost two months, so knowing

63

that he had been transferred to a different yard within the prison, I called up the office to double-check his address. A very service-minded man told me Michael had been moved from the C to the B yard. But it shouldn't make a difference, the soft-edged voice said to me on the phone, any letter that arrives in the prison makes it to the prisoner eventually. Eventually.

Finally, on January 4, I received notice that there were letters at Jmail, and found that three letters had arrived, on December 5, December 14, and then January 4. I know for a fact that the letters of December 5 and 14 were not in my Jmail inbox before January 4; I had been checking. This reveals another condition to the age of our tide (outside of printing, scanning, posting, prison bureaucracy): random digital glitches. Michael wrote:

> I am sitting here very frustrated because it seems like you have not received any of my letters. So far I have sent about three of them.

Adding to his frustration was the fact that I had sent some of my letters twice, because I thought I had the wrong address.

Michael also repeats himself. Tells me three times how to set up a Global Tel Link account so we can talk on the phone. Tells me the approximate percentage of homosexuals in the Sensitive Needs Yard: first 80%, as we get closer to Christmas 85–90%.

"But I think I figured out the problem," he said: "I've been sending brown recycled indigent envelopes that the prison stamps and sends out themselves. Maybe they have not reached you yet. So for right now, I'll send this letter in a regular envelope with an actual stamp."

What had felt like nodes—the swelling knob on the straight line of a green stem, or the intersection of a planet's orbit with the celestial equator—now seemed to me not

64

natural or coherent, but man-made and arbitrary, simply a type of control: time between us was a brown envelope.

As time came to a halt with those letters in December and our temporalities entangled, distance between us also seemed lessened. Not only had the guard I spoke to on the phone actually been in contact with Michael to let him know I called—there had been just one voice, one physical presence between us, a new medium of communication—but our connection in the more abstract, affective sense was also strengthened. It was at the point of our sharing this desperate kind of stunted, limping time that I had written him again and again, unsolicited and in spite of his apparent silence. Written about trivialities, outlining my emotional hardships, gone off on tangents about politics. And he too had begun to confess to me things that he said he could not tell anyone else, "I feel I've found a real friend in you," he said, eventually, "do you feel like that too?"

Time had irrevocably both stopped and run ahead of us. The time-space of over a month arrived with an e-mail notice to check my Jmail inbox on January 4, and I realized that, even if I had never had any intention of turning back, I now had no choice but to stay in the fold.

I want to add to the geography of the prison-industrial complex and the space of our correspondence a temporal aspect, which seems at once to compound its conditions and produce cracks in it. So what is it like, this fold? What characterizes it? It begins with a loss, say, the loss of your seat at the table that is society, a crisis, and then: the arrest of time, or the time of arrest.

"The flow of time stops and swells up into a large pool," writes Denise Riley, echoing both the arrest of difference experienced in prison as well as the stillness of an ocean without waves.[44] But her essay *Time Lived, Without Its Flow* in fact describes the effect that loss and mourning can have on your perception of time. What arrested Riley's time was

65

the tragic passing of her child. "So if time has stopped, have you stopped?" she asks. "Admittedly something still goes on, but in essence you have stopped. You're held in a crystalline suspension. You are pure skin stretched tightly out over vacancy. You abide."[45] The loss that she testifies to is quite different from that inflicted by incarceration, which takes not a life in its entirety, but aspects of it: a deprivation of the senses, of movement, of potential. Still, her condition resonates with Michael's insofar as he is also "suspended," a life deferred until later. It is a state that leaves you with little choice but to abide, and reduces your world to the silhouette of what is no longer there. "The world is so much bigger than this Kristian," he wrote to me, "the world is waiting for me."

"Well let's just say," Michael had said, back in November, "that for some strange reason I started having mental health problems." Perhaps I should have known, but because of the way he had said it, I thought it was a trick. But by late March another condition had been added to the age of our tide. Michael wrote: "I've been having some serious depression." "Truthfully I haven't been able to write any letters to you … The doctors have put me on some antidepressants, and they seem to be working as I'm feeling a little better." Feeling well enough to write, anyway.

This letter was much darker, as if a loss of outside added to the loss of movement induced by the inside. "I truly have no friends … you're the only one that keeps writing to me, the only. one." With the letter, Michael also sent a poem he had written. It reads:

Where I am there is no day or night:
time is frozen

Visions of normalcy become a blur

66

A place where either imagination & hope
revives you,
or anger and hate consumes a life.

A place where pride and humbleness are
constantly at war

A fear of change, a fear of success,
has driven us to devise an alter-ego,
consequently sustaining itself only through
criminality

But there is still the question, who are you
really?

Who am I really?

I guess after learning from my transgressions
I'm someone who wants to live for the future.

In some ways, experiencing time as frozen is like being at
once outside and inside of time, as in Riley, "you *are* time, you
are saturated with it."[46] The way in which her time has halted
is "like a sharp tear across a sheet of cling film: all bright
and still." In this state, she writes, you might develop *akine-
topsia*; "a condition of mislaying the perception of motion, in
which patients will find it hard to pour a cup of tea, because
the liquid appears to be frozen like a glacier."[47] This is a kind
of clean break in which you not only feel as if there is no pos-
sibility of a future, you have no desire for it either. But as
Michael's poem continues, an ambivalence to his situation,
which differs from Riley's, emerges.

A place where either imagination & hope
revives you,
or anger and hate consumes a life.

Back in August he had written: "Prison is stressful, it's not peaceful. No one is happy in here, but I am happy for the most part." And then in December: "The only thing that keeps me sane is exercise, basketball, TV, and school." While for Riley the release from futurity is also *relief,* in prison, the loss of futurity is a loss one simply can't afford: there is no coming back from it. It's the difference between witnessing the unbearably empty chair of the dead child, which makes chairs and tables redundant altogether, and not having been asked to the table at all: you can't stop staring at it. Michael needs his associate degree credits for when he gets out, as well as to move into the next moment: "School is very important to me in prison because it offers me hope & a sense of moving forward in a positive way." It's that simple, and even in the darkness of late March, he ultimately clings on to this sentiment:

> I guess after learning from my transgressions
> I'm someone who wants to live for the future.

The difference between Riley's loss, a loss that is final and personal, and one that is politically or institutionally induced is an important one. For Riley, it results in a collapse between what constitutes the self and what lies outside of it:

> If the membrane that thinly separates your interior from the outside world ... were to tear through, there's so little behind your skin that you would fall out toward the side of sheer exteriority. Far from taking refuge deeply inside yourself, there is no longer any inside, and you have become only outwardness.[48]

For Michael, the loss occurs in the exact same moment as the hard line between inside and outside is drawn. In fact, the very idea of the outside is constituted by this loss; this is the

heart of punishment: "The world is so much bigger than this," and he knows it all too well.

Prison erases the past only to push you inconclusively into the next moment. "This life of right now seems so blurry," Michael wrote to me just before New Year in 2015. Michael doesn't have access to his own past letters, he doesn't remember what he said, so he repeats himself; he is not sure I have received his letter, he repeats himself. With each repetition things become blurrier: 80 or 90%—what is the percentage of homosexuals in SNY? This repetition testifies to something other than vacancy behind the eyes, rather a constant search, anxious anticipation.

The time of not knowing, of no response, that I went through, waiting for Michael to use the white envelope instead of the brown one, or for the glitched algorithm in Jmail's server to sort itself out—a time determined arbitrarily—left me with a faint idea of the precise brand of monotony lived by Michael in prison every day.

Truthfully, yes,
the only way to describe it is monotony.
The only thing that keeps me sane is exercise,
basketball, TV, and school.

"You ask if I get stressed out: truly the word is monotony." I trip over this pair of words: stress, monotony. Stress is too many things at once: loud noises, incongruous impressions, a marketplace, a busy street. The stress of the monotonous is like torture: a drop of water falling on your head again and again and again.
This stress is different,
a continuous reorganization of the same pieces of a puzzle, how it is non-sensical that they all go together—basketball, TV, school—in whichever order.

A few days before, I had not considered the possibility of a tide in the laguna where we camped on the coast of

69

Chile, back in Santiago I had seen this artwork: a calendar of the year 1973 by the artist Alfredo Jaar. For Jaar, the year progresses in normal fashion until this date: September 11—the day General Pinochet blew up the parliament building in Santiago and overtook the government. The structure of the months that follow remain: October, November, December, but all numbers have become just one:

11.

Like beating your head against the wall, the nightmare of rolling a die and seeing the same number of black dots every time. Basketball, TV, school, truly the word is monotony: waking up every day on the same side of the sharp division *before* and *after*, all other differences become blurry. But in Jaar's work, repetition is ambivalent. Every day as the 11th is not only captivity inside of a dictatorship, it is also the refusal to move past it—to (en)counter it again and again and again, and with each day try to shake it, displace it, break it. The past extends itself into the present from a certain point, and the collective inscribes itself onto individual bodies.

The subversive potential of this ambivalence, for the Swedish academic Fanny Söderbäck, constitutes a kind of "revolutionary time."[49] A way of breaking with the binary of linear versus cyclical time, revolutionary time is living at once the present, past, and future—a recurring repetition, not of the same, but of a continuous displacement. In understanding displacement as an effect of repetition, we might think of how, in the philosophy of Gilles Deleuze, difference is constituted by the very accumulation of repetitions. Like the sound of a bell tower; with each ring, meaning shifts. With each ring, there is the possibility for subversion.[50] Judith Butler refers to the *iterability* of a thing; how the social as a series of citations leaves room for misquotation.[51] If we are to act politically—resist or revolt—we might even have a duty toward misquotation, toward the displacement of meaning through time. For Söderbäck, the displacement required to

70

make time revolutionary occurs by returning to the element that linear time has always erased: the body. "It is the body," she argues, "that can deliver the dynamic layer that temporal models have so far been missing."[52]

Anni di piombo (the Years of Lead) names a time of upheaval or crisis in Italy, beginning in 1968 and extending into the 1980s—covering the same tumultuous era in which Pinochet blew up the Chilean parliament, but on the other side of the Atlantic. Lead, perhaps because it was a time thick with bullets flying through the air—assassinated policemen, abducted politicians, bombs going off in railway stations—or because it was heavy,

Slow.

Whatever speed "normal time"—the time *before*—had moved at, during The Years of Lead time slowed down, repeated itself, took on a density that might have seemed like *more times at once.*

Like time in prison, the lead in question here is ambivalent. The accumulated repetition of powerful and dangerous manifestations of the militant Left, which constituted the potential for revolution, produced a violent backlash from the state. After the kidnapping and murder of former prime minister Aldo Moro by the Red Brigade, thousands of people were imprisoned on vague and unsubstantiated charges of subversive action against the state. Among them was the Marxist theorist Antonio Negri, doing time in various prisons from 1979 to 1983. During this period he wrote a series of letters to a young French activist named David. In doing so, Timothy S. Murphy writes,

> Negri was trying to set the power of militant desire flowing again, so as to build a pipeline that could serve at least as an affective and conceptual—if not physical or legal—line of flight from the prison's and the state's rigid walls, which had closed around all of them.[53]

71

David is a conceit. Not a real person, or at least not a singular person, but a composite of many comrades. The construction of an addressee, this young revolutionary, adds a generational dimension to Negri's project—a sense of time experienced differently but simultaneously, then passed on, shared, between people—makes a fold in time, pushes the past up to the present and extends the future into David. At the beginning of the New Year 1982, Negri describes how the writing process takes him back

> into circuits of imagination. New Year 1968:
> the wires of this story hum and tinkle sharply,
> like telephone wires in the wind in the old
> days. [54]

All the new years, all the years of lead, as if in a pile between him and the accumulated or collective mass of David. Though his body is imagined, but because it listens, because it is delineated by its name, it is a body nonetheless. As Söderbäck argues, the fact that these fleshy entities lived through those moments, and still do today, is a displacement to linear time that sets the wind in motion; produces flow through the pipeline.

Mara Lee's book *The Writing of Others: Writing as Resistance, Responsibility and Time,* as well as the e-mails we've exchanged around it, have been very influential to my thinking. Her pace and diction exists in this text in an almost physical way, like both ends of a correspondence become one. About Söderbäck's revolutionary time, Lee writes:

> Perhaps revolutionary time above all is a creative time,
> reserved for the writing, creating and thinking subject
> who actively manages to seek out and return. This will,
> this active seeking out and this
> transcendence
> risks overlooking bodies for whom the categories pastness
> and futurity scarcely constitute temporal self-evidence. [55]

72

This is what time is like for Michael: not self-evident—or, as Althusser would say, obvious. Or rather the stable progression of it is not self-evident. The present—stretched out some twelve years determined by the rhyming couplet "gun-done"—is the result of a single moment in the past, and the future is not as easy as tomorrow, but light at the end of a tunnel, that if you blink, you might lose sight of.

In getting to grips with the situation in which my correspondence with Michael takes place, I reach for other moments of crisis, other stoppages of flow. Like Riley's deep personal sorrow, or the language of the post-holocaust, a collective, historical crisis the likes of which the world has never seen. Is this hyperbolic? Or irreverent, like Max Frisch wrote of Paul Celan's naming of the death camps: impermissible and egregious? "It might be," Lee wrote to me, "but perhaps necessary, and in any case highly significant." Celan found himself in the middle of the postwar question of the legitimacy of writing literature *at all*. And it is not just a decade of Michael's life caught in a temporal fold, but millions of people's; the carceral state as bureaucratized warfare. In his book *Absent without Leave*, Denis Hollier writes about World War II:

> War institutes a regime of total mobilization that takes away time from writing. Freedoms are suspended. War essentially holds suspect anyone who finds time to write.... [Marguerite Duras] is seated at a table in the Orsay train station, taking notes, interviewing refugees. An officer appears. 'You're allowed to work standing up, but I don't want to see this table anymore.' ... War removes the support structures, the foundations, on which writing relies ... Nothing stable on which to write. Literature is no longer based on anything.[56]

As your freedom is suspended you lose your place at the table, your chair. On a personal level, that loss is a crisis, that loss can constitute a war. "To tell someone with a dead child

73

'you should move on' is doubly thoughtless," Riley writes, "because there is no medium left with which to move anywhere."[57] "Truthfully I haven't been able to write any letters to you as I've been having some serious depression," Michael wrote. *No medium left*. Like writing, for instance. Of course what is implied by revolutionary time, displacement through repetition, by misquotation, is not "you should move on," but rather a kind of combatant encounter with time, like Jaar's calendar: a conscious, thinking effort. But it is clear that one requires a chair and a table, stability, strength in order to even begin.

The California Department of Corrections and Rehabilitation runs a rehabilitation program with the slogan "The Right Inmate in the Right Program at the Right Time." The aim is to "break the cycle of incarceration" by *doing it right*. Having a high school diploma or associate degree is one of the key factors in ensuring fruitful "community reentry," for instance. It is the right program for any inmate, and for anyone in touch with an inmate it is the *right* thing to encourage. Where does the necessity of rightness leave "misquotation"? Remember how Genet's novel achieves a kind of truth because it begins with a negation: *failing* to understand. Michael cannot, *should not*, fail or practice resistance through misquotation. What use is the iterability of a thing when you have *no medium left*?

In the postwar context this was no longer a question of practical ability but of metaphysical possibility, of tact, and, I guess, solidarity. What does it mean to once have lost your chair, your table, or to know that, for many others, this continues to be the condition for writing? Is it proper for me to write, knowing that Michael can't in the same way? Today, the answer to this question seems obvious, but it still requires a certain awareness, requires that *anyway*. Not just the risk of failure, but its self-evidence. Mara Lee calls writing in this paradigm an "irreverent act of love";[58] to push through that paradox; to live more times at once.

On March 30, I wrote to Michael:

> I was so happy to hear from you finally yes-
> terday. Among the different causes for the
> delays to our correspondence--brown enve-
> lopes, glitches in Jmail's server, etc.--this
> is the saddest one. I am so sorry to hear that
> you have been feeling depressed. And so much
> so that you have not been able to write. I
> understand that you can feel so down that you
> can't even see where you might reach out to
> for strength, but please, try to remember next
> time: *write*.

In *The Writing of Others,* Mara Lee writes:

> The grand narratives have never been mine, but the body,
> the letters, are mine. I move in different ways every time
> I sit down to write, I vary my captivity endlessly.[59]

Her captivity is of course different to Michael's, the captivity
of the body, being a non-white woman living in a white man's
society. By utilizing time as a dimension, writing can pro-
duce distance, space—it reproduces a version of reality and
in that reproduction there is room for change, for movement.
"Please don't despair," I wrote to Michael on March 30,
"Write me letters and I will respond."

REHABILITATION

"Who am I really?" Michael asked in that dark moment—
late March, the poem.

I am someone who wants to live for the future.

I have been working around a series of re's, trying to decide which one to go with: responsibility, repetition, recognition, reciprocity. Like Mara Lee, or because of her, my initial instinct was to arrive in the end at *resistance.* "How do we resist or subvert? How do we find new subject positions?" Questions like these are so commonly asked in cultural studies departments. Questions, I realized, more appropriate for "writing time"—thoughtful, creative—a certain kind of writing even: this kind. But Michael has to live for the future, he needs somewhere to write from, as do I, writing to him (sharing his fold). Following my use of *Sittlichkeit,* I want to think about rehabilitation.

But first, something significant happened to displace this idea: a new addressee. Michael told me about him back in August:

> Yes, I found a boyfriend in prison, the sweet-
> est guy, his name is Luke* but he transferred;
> I'll always love him and hold dear the times
> we shared together, even though we can't be
> together in the street he is like my best
> friend.

Already at that point Luke had transferred, but I don't know how long before. It could have been years since they last saw each other. Luke was initially transferred to Salinas Valley in Soledad, California, and from there was transferred again, but Michael didn't know to which prison. This is where he needed my help. I did some research and found Luke at a facility some two hundred miles south of Michael's. He is serving a twenty-year sentence for robbery, which he began in 2002, and which aligns his estimated release with Michael's. I don't know why they can't be together in the streets. Like with Michael and me, it could be any number of reasons. Luke is white. Maybe he is not fully out. Maybe Michael worries they're too different. Maybe Luke does. In any case, Michael

*This is not Luke's real name.

had received some disturbing news, and on April 9 wrote to me "with the most desperation." The letter I'm about to quote from was addressed to Luke, but Michael is okay with me using it:

> Tonight I had dayroom & I met this guy named
> Charlie, he said he came from Salinas Valley.
> Immediately I asked him if he knew a guy named
> Kevin, he then asked "Luke Anderson?" I said
> yes, he then said, "uh yeah, he's in the hole
> because he rolled it up from a drug debt."
> Luke, as soon as I heard this it felt like
> my stomach turned upside down. I feared that
> there might be a lot of drugs at Salinas & my
> worst fear is that you might get an itch to get
> high again.

So Luke's in the hole, that is, he started using again, there's a debt involved. In one of the most passionate letters I have ever read, Michael urges him to "stop that shit" for the sake of their future together. This introduces another couple of re's: relapse, recidivism. The latter, especially, is rarely in colloquial use. It is a term that is shared by the medical and legal dictionaries: a tendency to relapse into illness or addiction, to relapse into criminal behavior.[60] Given Michael's own recent battle with depression and the risk it represents of relapsing into darkness, of losing sight of the future, these re's seem particularly important to the question of what one might do, if not resist, within the prison context.

"In much of the criminological and clinical scholarship on rehabilitation," the sociologist Philip Goodman writes, "recidivism is taken as the only outcome worth measuring. Exactly what recidivism is assumed to reflect and why it is the best (or even sole) measure often goes unstated."[61] To not recidivate becomes the very definition of rehabilitation, the negative imprint of an object whose substance is in itself unknown.

77

Goodman wants to take time to ask: Why recidivism? What do we really mean by rehabilitation?

This question of definition is relevant to resistance as well. In response to her critiques of whiteness and racism, Sara Ahmed is often met with these demands: to say what we should do instead, to determine how we can resist, preceded by the assumption that "we" must do something. In "A Phenomenology of Whiteness," she writes:

> You become obliged to give evidence of where things can be undone; to locate the point of undoing.... What does it mean if we assume that critiques have to leave room for resistance, as room-making devices? This desire to make room is understandable.... But this desire can also become an object for us to investigate. The desire for signs of resistance can also be a form of resistance to hearing about racism. If we want to know how things can be different too quickly, then we might not hear anything at all.[62]

To ask what we really mean by resistance or rehabilitation, then, might actually be part of the solution, not just the critique. And taking recidivism rates as the measure of successful rehabilitation, following Ahmed, is to not listen carefully enough to the response. It is to not hear, although shouted from every rooftop, the problem of rehabilitation as an expression of the senseless violence of mass incarceration as industry. To not get stuck looking for evidence, whether of resistance or the failure of rehabilitation, but instead to listen, requires an opposing question. One which Mara Lee poses:

> Not "where is resistance?" but: "When do we manage to recognize something as resistant?" ... Is it when white middle-class bodies protest in the suburbs? Or can resistance be something different, something small, barely discernible?[63]

Rehabilitation might become a kind of displaced resistance, something much smaller, something that has to do with waiting and with questioning what we mean by rehabilitation, and how we recognize it. When I introduced my project to Lee, I introduced it as a displacement of hers: not *The Writing of Others* but *Writing With Others*. That is, a shift from the nature of otherness *within* the writing subject itself, to the relation *between* one subject and another. I asked her: What do you think happens in that shift? "It implies a broader question," she responded, "that also involves the act of reading. And a set of 'couples,' like 'reading/writing' and 'subject/object.'" These pairs bring us back to the presence of a paradox: the object that is destroyed yet survives.

Sara Ahmed writes: "If we start with the body that loses its chair, the world we describe will be quite different."[64] This is the chair from which we would explain away the paradox and see just inside/outside. Remember how *Sittlichkeit* means morality? Yes, *Sittlichkeit* is completely bourgeois, tables and chairs, too—the patriarch sits at the end of the table on his chair, and the philosopher is in his arm chair, the user of objects, like Hegel with his jug and Sartre with his paper knife—*we know this*. But at the same time, Ahmed recognizes that not having a chair renders you not a user of objects, but one among them. You can only circulate around the room for so long before you get the idea to pick up the philosopher's jug and smash it, and then *you go back to prison*.

*

I have been working for some time now, following Michael's instructions, on setting up an account with Global Tel Link, a private company that manages phone calls out of correctional facilities across the United States. My mobile number becomes monstrously long, fifteen digits, when dialed from outside the US, and Global Tel Link call me up to test it. I am

79

in touch with a lady named Denisce, who is continuously uncertain about my gender. Mrs. Madsen, she addresses me, "thanks for setting up your account," "Good Morning Mrs. Madsen, I can't guarantee your payment will not bounce and be sent back to you via Western Union minus a $15.99 fee." Due to her multi-cultural background, Denisce explained to me, she finds it hard to determine someone's gender based on their name, she apologizes for any offense, but can't guarantee my payment all the same. And continues to call me Mrs. It can take up to three weeks before I will know whether my payment has bounced or not. It will take three weeks anyway, I think, for Michael to get the letter with my phone number. Should I transfer more money straight away? I have to pay Western Union in advance and we get to talk for fifteen minutes at a time—that's all I know. I don't know when he will call, I don't know how far thirty dollars will get me, us. The user reviews for Global Tel Link generally complain it's too expensive, even to US landlines. What about UK mobiles? But none of us waiting for calls on the outside have any other way. The option to leave a user review is polite but absurd, given that there is only one company. It's like leaving a user review for the prison, as if you could choose to take your business elsewhere.

Michael has been asking about the phone call almost from the outset, but it was one of those questions I found it difficult to respond to. I was quite content, I suppose, with the letters. It was easy enough for me, and interesting. But after the time-lapse we experienced before Christmas— the brown envelope and the extent to which our correspondence was made to slow down—it began to seem more practical, necessary even, to talk on the phone. With Michael's depression necessity turned to urgency: "I truly have no friends…. You're the only one that has kept writing to me, the only. one." I transferred the money and told Michael to call me in three weeks. He wrote back that my phone number was too long. But it has been cleared and

tested by Denisce at Global Tel Link, I replied. At this point, I've taken two months to make a thirty dollar transfer that Denisce still can't guarantee will not bounce. It's not like I'm curing cancer here, so why does it feel like that—like this isn't meant to happen, like I'm swimming against the stream, or trying to change the tides?

*

In March 2008, the California Department of Corrections and Rehabilitation conducted a ten-day operation referred to as operation "Changing Tides." The goal of the operation was to reduce the negative influences that hinder the reha- bilitative process and the full integration of inmates in pro- gramming and housing assignments.[65] The implementation of the Integrated Housing Policy as well as "Changing Tides" can be seen as part of a shift in institutional attitudes toward incarceration that began, at least symbolically, in 2005 when the California Department of Corrections became the California Department of Corrections and Rehabilitation.[66]

There are two tides at play here. The tide implied by the ten-day operation is individual to each prisoner, a chal- lenge: *Can you change your tide?* The tide that might be changing along with the name of the California Department of Corrections in 2005 is something more general, like "the nation's attitude" toward rehabilitation. Does the taxpayer believe in human malleability? Does the doctor believe the illness has a cure?

Tidal forces are big waves generated by the sun and the moon that travel around the oceans. Their travel time depends on a series of factors like coast orientation, continental shelf margin, and water body dimension. There is an irony, a radi- cal cynicism, or just brutal honesty, to this image. Imagine the California coastline shifting, earthquakes, and collapsing cit- ies; or the moon and the sun changing lanes, changing every- thing, all the fish in the oceans taking different turns.

The implication is that to change attitudes toward rehabilitation in the American prison system would be a change of tidal proportions. The basis of the current attitude was formed in the 1970s when Robert Martinson's hugely influential report on rehabilitation "What works?" proclaimed that, well, "nothing works"—it became a kind of doctrine for decades to come.[67] In his book *Thinking about Crime* from 1975, Harvard scholar James Q. Wilson popularized a similar opinion: "Wicked people exist. Nothing avails except to set them apart from innocent people."[68] That Wilson has since received the Presidential Medal of Freedom reveals the extent to which the very notion of freedom relies precisely on "setting apart," that is, on mass incarceration. But the logic doesn't stop here. In the 1970s, Michelle Phelps argues in the *Law & Society Review*, rehabilitation not only became a dirty word but *a natural impossibility*:

> A world radically changed by historic events—such as the Vietnam War, the bombing of Hiroshima, and the Watergate scandal—reduced confidence in the malleability of human nature and the capacity of any government institutions to produce such changes.[69]

Vietnam, Hiroshima, Watergate. The malleability of human nature. This is much bigger than any one inmate.

If in the socio-medical model of the 1950s and 60s, as Philip Goodman argues, prisoners were seen as sick and therefore curable and in need of treatment,[70] how might we see them now? Legislation such as "Three Strikes and You're Out" (1994) and "Use a Gun and You're Done" (1996) sounds like a doctor with a bad sense of humor passing on a death sentence. Also in 1994, the Clinton administration legally excluded prisoners from applying for Pell Grants for college education: you're out, you're done, you're down, the system seems to say.[71] Recidivism rates hover fairly stably around 60%,[72] that is, over half of California's prisoners return to

correctional facilities within three years of their release to hear it from the doctor again: there is nothing we can do, *nothing works*.

This moment, the doctor's diagnosis, constitutes a crisis for two reasons: *krisis* means judgment, and *krisis* also means the "turning point in a disease." That moment when it can go both ways—*what is the doctor going to say*. But then what is said is contradictory. The Martinson report says "nothing works," but the United States of America says "it's a free country," its ruling ideology claims "it's a fair fight." The moment of crisis is prolonged, the prisoner held in suspension. So: What is the nation's attitude toward rehabilitation?

In 2015, the Obama administration announced a temporary Second Chance Pell program to reintroduce the federal grant to prisoners looking to enroll in college. "The United States is a nation of second chances," the president said.[73] Buses drive around London advertising a diet pill with the slogan "Give your body a second chance." It's this kind of logic: *you too can change your tide*. I could probably get up earlier, be more productive, more positive, more efficient—why don't I renew myself, like get a haircut, lose weight? Every day is a reentry into society, a challenge to optimize myself. *Everyone needs a second chance; everyone is in danger of relapsing*.

The title of Philip Goodman's study is *"Another Second Chance": Rethinking Rehabilitation through the Lens of California's Prison Fire Camps*. The prison fire camps are a highly publicized alternative to incarceration in California in which inmates are put to work doing manual labor projects and fighting wildfires. "Correctional administrators, politicians, and the media all celebrate the camps as efficient, positive, and productive places with the potential to transform criminals into responsible citizens," Goodman writes.[74] "The fire camps are infused with messages of rehabilitation," he continues, so how can they "survive, even flourish, within a larger penal environment that appears in so many ways hostile to a rehabilitative, comparatively less

83

austere, imprisonment approach?" One plausible answer—
much the same as the reason why the US is a "nation of sec-
ond chances" and why I could probably get up earlier—

> is that the camps are the proverbial exceptions that
> prove the rule.... Indeed, there is some evidence that
> those who live and work in the fire camps think of them
> as exceptional spaces ... [and] inmates and frontline staff
> view rehabilitation as something that happens if (and
> *only* if) people want it to happen—essentially, individu-
> als are considered responsible for their own rehabilita-
> tion. The understanding of rehabilitation in the camps
> is, then, largely compatible with the neoliberal penalty
> embodied in California's walled prison complex.... Seen
> in this light, rehabilitation exists in the camps not in
> spite of the punitive turn, but in many ways precisely
> because of it.[75]

According to the anthropologist Aiwah Ong, exceptional-
ism is central to neoliberal ideology in two ways. The United
States, for instance, is constituted as exceptional and excep-
tionally free through the construction of other, unfree
places—remember, the ~~outside~~ is because the ~~inside~~ is, too—
while exceptions to neoliberalism, states of exception in
which freedom is actively suspended, are routinely justi-
fied in the name of that same freedom.[76] In other words, a
contradiction. The prison fire camps illustrate both types of
exceptionalism in being simultaneously camps *and* prisons:
"the work performed by inmates is seen as heroic, rehabilita-
tion-oriented labor as well as exploitation; and those incar-
cerated in the fire camps view themselves (and are often
viewed by others) as *both* heroes and prisoners."[77]

The (re)turn to rehabilitation suggested by the depart-
ment's name change in 2005 and the various initiatives that
followed is therefore highly tenuous, since the dominant
neoliberal logic is also a punitive logic. That is to say, while

the foundation of this logic goes way beyond the agency of any one inmate—Vietnam, Hiroshima, Watergate—rehabilitation within it does not. Michelle Phelps confirms this:

> Whereas in [the 1960s] the institution explicitly emphasized its own responsibility to provide a healthy and productive setting for individuals' development, in 2001, responsibility was placed solely on the inmate to behave well and seek out opportunities for self-development ... Staff members articulated a neoliberal personal responsibility framework where inmates were responsible for their own reform and staff were responsible for maintaining order and security.[78]

Michael subscribes to this idea too—he has to:

> I'm embracing my consequences and trying to better myself as a human being. As for right now I am staying away from drugs and alcohol. My dream is to become a drugs & alcohol counselor. I want to earn a bachelor's degree in psychology. I love studying about the brain and how it works.

Bettering himself as a human being is defined by recidivism both in its medical and legal use. "It is what it is," Michael said of his situation. Looking back now, I am not so sure of my response:

> You're right, *it is what it is*, but it is not a consequence that is yours to embrace. You have to feel in whichever way best helps you to deal with your situation, but don't feel bad, don't feel like a bad person, or think that bad things happen to bad people --that's not how it works.

I'm convinced this is true: that's *really* not how it works. But what good does that do Michael now? It *is* his consequence to embrace because he is embracing it—*for twelve years.* Sure, Obama's Second Chance Pell program brings Michael's bachelor's degree further within the realm of the possible, but on the whole, the state is not interested in rehabilitating inmates. There are whole books written about why this is, but to sum it up, while the prison system is a "billion dollar failure" for the state, it is also a "billion dollar industry."[79] "If we were to return to the imprisonment rate of the 1970s we would have to release four out of five prisoners," Michelle Alexander writes in *The New Jim Crow*: "one million prison staff would lose their jobs."[80] Not to mention companies like Jmail, Global Tel Link, and Golden State Care Packages, their employees and their profits. For this reason, any turn toward rehabilitative strategies has happened out of desperate necessity; a prison system running, for much of the last two decades, at 200% capacity. In 2011, the US Supreme Court's decision in *Brown v. Plata* "demanded the state reduce overcrowding by nearly 40,000 inmates in order to remedy prison medical conditions that were so abysmal as to be clearly unconstitutional."[81] This ruling probably had something do with the 2012 amendment to the Three Strikes rule, which requires the third felony to be a "serious or violent" one in order to justify the twenty-five-to-life sentence.[82] But overall, *Brown v. Plata*, which since became known as the Public Safety Realignment Act, has been deemed not much more than a "reallocation of responsibility"—that is, it has not resulted in the release of prisoners or law reform, but largely the transferal of prisoners out of California's state prisons to county jails or facilities in other states.[83]

This introduces two more re's, realignment and reallocation, which confirm that rehabilitation is, in Goodman's words, a "rhetorical shell."[84] These two re's function as displacements of rehabilitation. Like the prison fire camps, "infused with messages of rehabilitation" *as well* as something

86

else, namely the exploitation of free labor. Prisoners are also heroes because they "view themselves (and are often viewed by others)" as just that; the two are part of a feedback loop. In Phelps's example, "staff members articulated a neoliberal personal responsibility framework" and, in turn, so does Michael in "embracing his consequences." The problem, as so often, is power, asymmetry: Who is the first to "view" and to "articulate" and who follows suit? Who determines the conditions under which the hero is even allowed to be visible, and who agrees to step into that gaze (if one can even speak of agreement)?

Michael's willingness to embrace his consequences is tied up with his desire for the future, a desire to be considered. It is part of the ambivalence of interpellation as that which both recognizes your subjectivity and determines its boundaries. "I do battle for the creation of a human world," writes Frantz Fanon "—that is, of a world of reciprocal recognitions."[85] But neither Fanon nor Michael live in "a world of reciprocal recognitions," when it comes to rehabilitation, interpellation is the name of the game: the greeting that tells you who you are, rather than asks. Fanon argues that when slavery was abolished in the French colonies black people did not gain new life as much as they were given a different way of living the old one.

At 60% recidivism rates, this rings true in the case of contemporary United States, too. Prisoners are given freedom on very specific conditions. They are not eligible to vote, for instance, and they're excluded from jury service—in many basic senses, even after release, felons are not recognized as citizens. To continue the parallel to slavery introduced by Fanon, Michelle Alexander writes with reference to the contemporary prison industrial complex: "We have not ended racial caste in America; we have merely redesigned it."[86] When applying for jobs and housing, prisoners are interpellated by a box called "Prior Convictions"; they tick it. They don't get a job; they don't get a place to live. Activists and

87

civil rights lobbyists have campaigned for decades to "Ban the Box" that would disclose prior convictions on job and housing applications.[87] In California the box was banned on public sector jobs in 2014,[88] but for housing, the last assembly bill on the matter was denied in February 2016.[89] *Black people did not gain new life as much as they were given a different way of living the old one*: nobody wants a criminal in their building, and once labeled a criminal you cannot be recognized as anything other. Doing time doesn't make sense as a concept if the time in question is de facto indeterminate. And so the struggle continues.

In those letters from April 9—his letter to me and the one to Kevin—it seems to me that through his desperation Michael is realigning his identity, creating different feedback loops. If not at a structural level, reciprocal recognition might at least be achieved somewhere closer to the floor, in relationships, listening, in daily life. "All I ask," Michael writes to Luke, "is that you stop getting in trouble & stop using; I know it's hard at times, and you know I have a problem with it too, but, trust me, we have to be strong for each other." So have I failed to understand Michael's condition? Yes, probably. But I don't have to, Luke understands, and Michael understands Luke.

"P.S." Michael finishes the letter: "Whenever it gets hard, think about us and our future together ok please." Luke wants to open a chess café in the Sacramento area. Maybe he and Michael can displacedly rehabilitate there, or at least for now it can be that view of the horizon people pay good money for.

"P.S." Michael also finishes his letter to me: "send me your cell phone number

that way I could call."

CHAPTER 3
Using People

June 2017

Dear Michael,

First things first. I was invited to speak
at a museum in Sweden in the autumn. The
occasion is the publication of a literary
journal in which a chapter from the text I
wrote about our correspondence is published.
The theme of the event is similarity and
difference in political alliances.

We wrote about this in one of our first
letters. Remember when I asked you if you
thought it was possible for two people in very
different situations to be in solidarity
with one another from across a vast distance?
And you said that if you make efforts to
really understand the other person, then yes?

Anyway. I was wondering whether maybe
you would like to write something for this.
I will say that you wrote it, and that I am
only reading it aloud on your behalf. What do
you think? It would be nice to do something
collaboratively, since the text I originally
wrote owes so much to you.

You can write whatever you want, I'm
totally open to anything. It can be funny or
sexy or violent or political or sad--anything
goes, as long as you're excited by it.
Think about it and let me know!

When I wrote this in the summer of 2017 I seemed to have
forgotten what I had written the year before at the end of the
introduction to "Doing Time":

That I *could* be in prison right now is not important, what is important is: I'm not, the ground beneath me is solid and a gun is a gun is a gun, you either have it or you don't. "Or what?," one might ask, as in, is that really true? or: *and then what?*

In the original document that I first handed in to my tutors at the Royal College of Art, I was playing around with words and images, and wrote that final sentence in white bold italics across a photograph of Warsaw in 1945, completely destroyed by the war: *and then what?*

In referring to Warsaw in 1945, what I meant to imply was that I was writing from somewhere fundamentally broken. The city is ruined but life goes on—a kind of ground zero from which the inequality between Michael and me was inescapable; violence had always already happened.

I return to that moment of crisis—the war and its immediate aftermath—a few times throughout "Doing Time" because it seems to have induced a similar kind of ethical dilemma into the literature as I had imposed upon myself, and which Michael was inevitably in, serving his twelve-year sentence for armed carjacking: the problems with and possibility of writing anything at all.

Remember what Denis Hollier wrote:

War essentially holds suspect anyone who finds time to write. War removes the support structures, the foundations, on which writing relies.... With nothing stable on which to write, literature is no longer based on anything.[1]

And remember his anecdote of Marguerite Duras, during the German occupation of France, seated at the d'Orsay train station taking notes and interviewing refugees when an officer appears to take away her little folding table and chair.

"You're allowed to work standing up, but I don't want to see this table anymore," he tells her.

About a month after I sent the letter asking if Michael wanted to collaborate with me on this lecture, I received his reply: "I think I have something for you," he wrote, "I hope you'll like this poem, and I trust that you'll take care of it."

"P.S. Could you make a copy of the poem and send it back to me?"

It was the same poem that he had sent to me over a year and a half before. It's included in "Doing Time," and I also gave him some feedback on it at the time.

Michael doesn't have access to his own past letters, and those that I send him—if he even keeps them, I don't know—do not seem to be in the same place as the table that he writes from. He doesn't remember what he wrote even in his last letter, much less one from so long ago. For Michael as for Duras standing up to take notes in the Gare d'Orsay, the support structures on which writing relies have largely been removed.

This is what I had forgotten: the city is ruined and life goes on—but for some more than others. I'm the one holding the pen here. The solidarity between us is a regime instated by me. Our reasons for corresponding are not the same—how could they be?—we don't share this project. It was naive to think there could be such a thing as collaboration.

*

Backtrack a little. August 2016. I was on a sailing holiday on a remote island on the west coast of Sweden, close to the Norwegian border. The sky was dark except for a slit of light lining the horizon to the north, and dead quiet. When at around midnight my phone rang, I immediately knew it was Michael. Frantically stumbling off the boat in the dark, Michael's voice on the other end was, as always, light and

cheerful. We talked for a few minutes before he handed over the phone to his celly, Charlie*.

I had been hearing about Charlie for a few months. He had a crush on Michael, which Michael, somewhat reluctantly, was beginning to reciprocate. "Such a sad story," Michael wrote, "I don't believe in many people's innocence, but this guy's I do."

In 2008, Charlie met an elderly man online and went for a visit to his house in Palm Springs. A few weeks later the man was dead and his bank account drained. The murder investigation and ensuing trial was highly publicized in the local media. By 2012 Charlie was sentenced to life in prison without parole for conspiracy to murder for financial gain. This doesn't make any sense, Michael told me, because Charlie already has money. Why would he do that?

Suddenly, I had Charlie on the phone. He told me he used to travel a lot. Stayed all the time at the Savoy Hotel in London, and studied at the Humboldt University in Berlin, the city to which I had recently moved.

"So, you're a writer?" he asks me.

I know what this is about: someone wrote a book about the murder, a tacky brand of true crime fiction, serif fonts casting shadows on a glossy cover. It looks shamelessly sensational, and highly lacking in credibility. Michael had aired the idea with me before that I should write something about Charlie's case to make up for the book. Something like: the true story.

When our fifteen minutes were up, their clear and energetic voices resounded incongruously amid the soft dim of the island. An echo not only from another time zone, but another temporality all together. I was breathless for a second, thinking: "How do I get out of this?" But also: what a way for the world to fold, what a total mind-fuck.

"I want to apologize to you, Kristian," Michael wrote to me in his next letter, "for bombarding you on the phone with my celly. Charlie is a nice person

* Not Charlie's real name.

and I would never have you interact with someone I didn't trust."

I told Michael it was OK, but that I had found Charlie's story a little bit fantastical: such a young man staying at the Savoy, among other things. Michael must have passed on the message, because a few weeks later I received a letter directly from Charlie, who wanted to explain himself.

Where Michael's letters are always handwritten on cheap yellow paper, Charlie's looks like it has been through a fax machine, and features an official-looking letterhead. His letter is elegantly signed off in blue pen: "Tschuess"— as Michael never fails to remind me, Charlie speaks fluent German. He also recommended me a hotel in the German capital: The Westin Grand, adding: "They filmed part of the Jason Bourne movies there."

Attached to the letter are contact sheets with over 200 photos from Charlie's life "prior to incarceration," as he wrote, from childhood until about 2007. The pictures are eerie: xeroxed black and white, the faces of the people are like ghosts, either disappearing into darkness or burning up. One photo shows "Mom & Dad," moustache and white fur coat, on a boat. The caption under another reads "My crashed Porsche." Another shows Charlie next to Kamala Harris, at the time, the Attorney General for the State of California.

In 2012, after Charlie's imprisonment and after California failed to fully implement legislation to reduce crowding, the same Kamala Harris appealed the court's order to implement new parole programs on the grounds that if forced to release inmates early, prisons would lose an important labor pool. Harris has also since supplied the tag-line—I imagine unwittingly—for the salacious page-turner spun out of Charlie's alleged crime in which she compares the case to a Hollywood movie.

In spite of these references to the world of fiction, for the first time in my prison correspondence, I felt like I had come closer to the reality of someone than I wanted to. My

correspondence with Michael had mostly been about our personal lives, never about what he "did," and he always followed my lead in terms of what he shared of himself. But, perhaps because convinced of his innocence, Charlie was proactive. Was this the reason for my discomfort, that he acted like a free man?

Receiving the contact sheets had the undeniable thrill of a scoop, and I started digging into the story online. There's a video clip from Charlie's trial, where he acted as his own defense. He apologizes for being a bad public speaker before opening his statement:

> You'll have heard me referred to in some rather colorful terms. Like something out of a Hollywood script or a Martin Scorsese. I don't know if that's supposed to make me the Gay Godfather, or what, but as Plato once said: to deceive is to enchant.

With a strikingly more pedestrian vocabulary, the judge nevertheless concludes the hearing: "Mr. Knox is guilty as hell." I replied to Michael's letter:

> The problem with getting someone to write a book about your crime is that they are always going to write the book that *they* want to write. Writing is deeply selfish and necessarily entails a transgression of boundaries: it transforms people into characters. The writer picks up on glitches or phrases and turns them into metaphors, makes the color of your eyes match that of the ocean, makes your love affair sound like a movie, your voice sound like a rain of bullets. Seeing yourself turned into an artwork is not an easy thing. Having had this crappy book written about him, I guess Charlie knows that, but having another one made could just make it worse.

Somewhat ironically, the details that I mentioned—"love affair like a movie," "voice like a rain of bullets"—are concrete instances in my writing about Michael that come up in "Doing Time." I am tracing a characteristic I know only too well.

In more than one way, I found myself in a similar situation and making an argument very similar to Janet Malcolm in *The Journalist and the Murderer*. In this seminal work, still taught on every journalism course, Malcolm tells the story of being asked by a death row prisoner to redeem his image in the press. She writes: "the moral ambiguities of journalism lie not in its texts but in the relationships out of which they arise, relationships that are invariably and inescapably lopsided." And, on the very first page of the book: "Every journalist who is not too stupid or too full of himself to notice what is going on knows that what he does is morally indefensible."[2] Malcolm's is a tough pronouncement on using people for writing or art. Still, she made a long and successful career as a journalist. She did it *anyway*.

It's worth revisiting Barbara Johnson's essay "Using People," which addresses this exact topic. She uses the child psychologist D. W. Winnicott's theory of the transitional object of a young child to outline a subject-object relation that is not only exploitative. The transitional object is one used by the child to detach itself from the mother, and understand itself as an independent subject. She thinks of the transitional object "not as object but rather as use-of-an-object"—a paradox that must be allowed to remain a paradox. "The properly used object," she writes, "is one that survives destruction"[3]—an argument that goes a some way to explain Malcolm's "anyway."

*

I met Naeem Mohaiemen in Stockholm in 2015. At the time his film *Last Man in Dhaka Central* was playing at the 56th Venice Biennale, curated by Okwui Enwezor. The film is

99

about the Dutch man Peter Custers and his involvement in revolutionary activities and subsequent imprisonment in Bangladesh in 1976.

Together with Chloë Bass, Mohaiemen conducted several long interviews with Custers at his home in the Netherlands. As I was writing "Doing Time" in the spring of 2016, Bass, Mohaiemen, and I corresponded over e-mail about the context of the film. It premiered in Venice in the spring of 2015 and by the autumn, Peter had died.

"At the time of his passing," Mohaiemen told me, "Peter was seeing a therapist for possible signs of post-traumatic stress syndrome. It is possible that the interviews triggered something with Peter that caused his health to deteriorate." After Mohaiemen finished the film, Custers admitted to him that while in prison in Dhaka he had been tortured and he had confessed details involving other revolutionaries, and that upon seeing the film, certain people in Dhaka might remember.

Following on from Johnson's argument: if the object does not survive, what, then?

The film is not expressly critical of Peters Custers—not at all condemning—but nor does it paint a simple, celebratory picture. Its success is that, in the twinkle of Custers's eye, Mohaiemen has captured something like *a whole life* that makes it impossible to come to a conclusive moral judgment, and even renders the idea of it beside the point. Still, it seemed participating in the work had been hard on him. After he died, Bass said to Mohaiemen: "We are used to thinking about art as a gift, but now I am not so sure." She elaborated on this comment by e-mail to me later on:

The heart betrays on all sorts of levels, and
although we were careful, I can easily say I
wish we had been more so. Slower, too. Because
that makes the story both more interesting and
less potentially destructive.[4]

100

On the subject of potential destruction, another flashback. In 1970, the American poet Robert Lowell divorced his wife of many years, Elizabeth Hardwick, a brilliant essayist, "though as good-naturedly as such things can be," as he put it in a letter to his close friend, the also-brilliant poet Elizabeth Bishop.

Two years later, Lowell used excerpts from Hardwick's in fact not-so-good-natured, rather angry and hurt, letters to him for a collection of poetry titled *The Dolphin*. "I am going to publish," he wrote to Bishop, "and don't want advice, except for yours." Her response was firm: "One can use one's life as material—one does, anyway—but these letters—aren't you violating a trust? IF you were given permission—IF you hadn't changed them … etc." "But," she concluded, "art just isn't worth that much."

Lowell won his second Pulitzer Prize for *The Dolphin*. When in spite of Bishop's criticism he went ahead and published the work, it was because "I couldn't bear to have my book (my life) wait hidden inside me like a dead child"—rather as if that child was his alone to publicly abort—and because, as he also told Bishop, "the letters make the book."[5]

I have also heard this said about "Doing Time." That its best, most vivid moments have Michael's letters to thank. The more real a fragment of life, the better the material is for art. "Real" being here the center of a semantic field that also includes pain, tragedy, blood, and bone.

In a 1963 letter to Bishop, Lowell had said this himself regarding the posthumously published poems of Sylvia Plath:

Have you read the posthumous poems by Sylvia Plath? A terrifying and stunning group has come out in the last Encounter. You probably know the story of her suicide. The poems are all about it. Of course they are as extreme as

one can bear, rather more so, but whatever wrecked her life somehow gave an edge, freedom and even control, to her poetry.

These poems, he wrote, "make one feel that almost all other poetry is about nothing. Still, it's searingly extreme, a triumph by a hair, that one almost wishes had never come about."[6] Hardwick, who devoted much of her own writing to understanding the personal costs of making literature, described Plath at the end of her life in similar terms; "alone, exhausted from writing, miserable—but triumphant too, achieved, defined, defiant."[7]

As we now know, what was published after Plath's suicide, her estate being managed by her ex-husband Ted Hughes, is hardly without controversy. There are many reasons to share or not share certain aspects of a life. But those reasons completely change based on the subject's ability take part in the conversation that ensues.

"We are used to thinking about art as a gift, but now I am not so sure," Bass had said about working on *Last Man in Dhaka Central*. "Naivety has a place in this," I suggested, asking:

Do you think one has to believe in art as a
gift in order to go through with it? Is it like
a kind of double thinking: aspiring to truth
in anything while being aware that there is no
such thing?

She replied:

Since Peter has died, our neutrality is now
even less than it ever could have been. We
have indirectly put together a final portrait
of his life. That we are left to present
that without him requires more of us, and more

102

personally, too. Yes, naivety--the belief in
art, as we're framing it--plays a certain part.
We are implicated as the living. We are impli-
cated in what remains.

It was this implication that Lowell decided to take the conse-
quence of for the sake of his art, but not so much on his own
behalf as on Hardwick's. As he wrote in *The Dolphin*:

> [I] have plotted perhaps too freely with my life,
> not avoiding injury to others,
> not avoiding injury to myself—
> to ask compassion ... this book, half fiction,
> an eelnet made by man for the eel fighting
>
> my eyes have seen what my hand did.[8]

As if, for Lowell, and in art making more broadly, eyes and
hands may be completely disconnected. Perhaps this is
another image of that naivety—the belief in art, as we're
framing it—the double-thinking that allows us to go through
with it anyway. I recently heard a Danish poet proclaim that
"poetry should never be afraid." Is this what he meant? Never
be afraid to disconnect. Bass again:

Naeem and I were discussing what it means
to "find people" in this way, and how artists
choose to bring different stories to light.
We assume that people want their stories
brought to light, and that we, as the artists
doing so, are providing an amazing opportunity
to the story's subject … [but] unearthing
stories can lead to all sorts of consequences,
both major and minor, and who knows what else
gets pulled up.

"Introducing publics to materials," she concludes, "is not an incidental process of aesthetic glory, but rather a complicated conversation." Remaining unafraid while understanding the complexity of that conversation seems to be the challenge for artists and writers after the anxiety of ethics.

What drew me to Mohaiemen's works initially was the parallel between the commitment of the subject to his cause—in this case—Custers to Bangladesh—and the meta-text of the artist to his subject—Mohaiemen to Custers. It is as if the doubling of the writer-subject dynamic exposes it as a kind of methodology, a way of implicating the writer in any critique of the subject—an admission of the inevitability of betrayal, as well as the impossibility of identification, while at the same time pointing to a way beyond it. Mohaiemen could pass no easy judgment on Custers, because Custers's vulnerability toward him and Bass is the same as his own toward the viewer of the work.

In his films, "time and space are out of joint," Mohaiemen told me. "Inhabiting other subjectivities (or failing to do so, while thinking you succeed) is one of my conceptual pivots." During the interviews that make up much of *Last Man in Dhaka Central*, everyone in the room is very aware of the failure of identification that glimmers from Custers's blue eyes to Mohaiemen's darker skin and Bass's American accent, the fact that one remembers 1976 more so than the others do. The leap one takes in daring to identify and then failing—*that* as a place to start.

This is also what attracted me to the work of the artist-musician Peter Voss-Knude. In August 2017, I saw him perform barefoot at a grand piano at the National Gallery in Copenhagen with his band Peter & The Danish Defence. His songs are smooth and melodic—his grip on the microphone was as firm as a soldier's on a gun as he swayed back and forth delivering his lyrics:

This is the corner where I killed my first man
don't run away
this is who I am.

He sang:

 have a closer look

This music-and-art project, which culminated in an exhibi-
tion at the Overgaden Institute of Art that summer, is the
result of three years of fieldwork, during which Voss-Knude
collected stories from Danish soldiers once stationed in Iraq
or Afghanistan. The voice that sings is neither his alone, nor
the soldiers', but an amalgamation of the two, Voss-Knude
explained to me. It's an odd couple: a gay, military-and mas-
culinity-critical artist and young army recruits, but some-
how they sing in harmony.

In the exhibition, the musical element was accompanied
by charcoal drawings and other visuals, depicting vaguely
homoerotic scenes of intimacy. Or perhaps this depends on
the eyes that see—someone used to homo-social interac-
tion between heterosexual men might have recognized these
scenes as completely void of eroticism. There was an other-
ness there that transgressed the specifics of experience,
such as sexuality: a sense that the intimacy achieved was,
not quite illicit, but *private*—different or othered—some-
thing between "what happens in Vegas" and a tree falling in
the forest, making a sound for no one to hear.

In his assemblage of music and visuals, Voss-Knude cre-
ated approximations and overlaps between his own iden-
tity and the soldiers with whom he liaised. On the floor, blue
spray paint—which soldiers would recognize as the same as
that used to guide you safely through minefields—spelled
out the word "LOYALTY."

Voss-Knude's amalgamation of differently othered posi-
tions reminds me of the American photographer Diane Arbus

who made a name for herself in 1960s New York photographing precisely subjects of difference: trans people, inter-racial couples, homosexuals, bearded women, identical twins—at the time, these all fell into the same category of "the curious."

In an essay for *The New York Review of Books*, Hilton Als wrote about Arbus's photographs that:

> they were on fire with what difference looked like and what it felt like as seen through the eyes of a straight Jewish girl whose power lay in her ability to be herself and not herself—different—all at once. The story she told with her camera was about shape-shifting: in order to understand difference one had to not only not dismiss it, but try to become it. "I don't like to arrange things," Arbus once said. "If I stand in front of something, instead of arranging it, I arrange myself."[9]

As Arbus wrote elsewhere: "Every difference is a likeness too." In "Doing Time" I wrestled with this question as well, but put it the other way around: that every difference is a likeness also means that every likeness is a difference, that difference is irreconcilable. But, I wrote:

> What exists between Michael and I is not for that reason an antagonistic irreconcilability, but one that stretches toward a political collectivity like a willingness to remain; to bear continuous witness to confrontation, and not to overcome difference.

This willingness can seem, in Arbus's words, "ghoulish"—a morbid fascination with death and disaster. She recalled seeing a lady fallen down on the street, crying for help, people flocking around her to look at the spectacle: "Is everyone ghoulish?" she asked, "I hate to have a bad conscience ... but it wouldn't have been better to turn away, would it?" This last question is one that could be applied to her whole oeuvre:

106

Would it have been better to turn away?

"Don't run away," Voss-Knude sang,
"Have a closer look."

Her daring, Als concludes, is what set Arbus apart from her peers:

> No visual artist of the twentieth century has described with more accuracy the enormous pride her characters feel at having risked all to become themselves despite the pain of being marginalized in their daily life.[10]

The "bad conscience" that Arbus nevertheless betrays in much of her testimony about her own work is one that perseveres— in my work too—and requires a little bit more unpacking.

Since meeting in Copenhagen, Voss-Knude and I have continued to correspond about our respective projects. "Something that struck me about 'Doing Time,'" he wrote to me,

> is a tone within the text that implies some
> sort of guilt over even wanting to approach
> Michael in the first place; a fear that
> the touch and attention you show him would
> necessarily lead to him being used. I would
> very much like to disagree and believe that
> the exchange you have created, while being
> not at all devoid of power relations, deals
> with these in an honest way.

He is right. There is a measure of guilt underscoring that project. In a letter to Michael I had actually written on the subject:

> As a child I think it integrated into my
> sense of self, this potential that I could be,
> fundamentally, a "bad person," that I could
> have done something bad without realizing.

107

As if "badness" is this one very concrete
thing that you either possess or you don't.
It comes back to me sometimes, this fear that
everything I have ever done, all my good
intentions and the reasons people have loved
me, the fear that all this could just be
undone by the revelation of some kind of "bad
nucleus" there all along. This is probably
a very normal fear to have. A very Christian
fear: a priori guilt.

A Christian fear, sure, but one that nonetheless has informed much discourse in the purportedly secular contemporary field of culture, spawning a moral panic around questions of appropriation and representation. In the September 2017 issue of the German art magazine *Texte zur Kunst*, the Cuban-American artist and academic Coco Fusco wrote:

> It is painful for me to witness how young artists focus solely on what they see as the individual "right" to represent a culture or history rather than looking more broadly at the policies and practices of art and educational institutions.[11]

She had said the same thing in a different way during a Q & A after a performance she did in Berlin in March the same year. That evening, Fusco, along with a cast of actors, performed letter exchanges between German colonial officials in Namibia, and testimonies recorded from the local population following a devastating genocide. The performance was the result of years of research into Germany's colonial archives. The question went: "Why are all the actors white?" Her reply was unflinching. I quote from memory: the people here have all volunteered at very short notice, and I think they did a great job.

If Fusco had not been who she is—and by this I mean intellectually superior to almost everyone and, also, of

color—could this question have undermined what had been at once an educational and incredibly affecting artwork?

She continued (again I quote from memory): I have white students who tell me they don't want to write about slavery because they're white, and I tell them, "No, you, precisely, should write about slavery."

A couple of weeks after Fusco made that statement in Berlin, shit hit the fan as the Whitney Biennial opened in New York. The artist Hannah Black called for the removal and destruction of an artwork by Dana Schutz depicting the mutilated corpse of Emmett Till, abstractly painted after a photograph published in various news media after the brutal lynching of the fourteen-year-old boy by the KKK in 1955. In an open letter, Black and others argued that Schutz, a white woman, was profiting from making a spectacle of black death.[12]

In an article published by *Hyperallergic*, Fusco entered the debate to oppose Black's position. She stressed that while she welcomes strong responses to art works,

> Black makes claims that are not based in fact; she relies on problematic notions of cultural property and imputes malicious intent in a totalizing manner to cultural producers and consumers on the basis of race.... Presuming that calls for censorship and destruction constitute a legitimate response to perceived injustice leads us down a very dark path.[13]

Black's horror at Schutz's painting echoes that of Elizabeth Bishop at Robert Lowell's collection of poetry. "Art just isn't worth that much." But where Bishop was speaking from a position of disdain for Confessional Poetry, of which Lowell was a prime proponent—disdain, even, for such unmediated use of life experience as raw material in art at all—Black does the opposite. For her, the personal is so political that the political in turn becomes the personal and

emotional property of certain individuals, and decidedly not that of others. This rush to automatically equate individual experience and expression with structural or historical violence is a potentially reckless way to handle some very heavy armory. Writing to Michael about guilt, I continued:

> I guess in prison you even have society tell-
> ing you that you're "bad" in precisely that,
> much too simplistic, way. That "one thing" you
> did, stretched out into a sentence. It must be
> very hard to maintain a sense of self against
> such a strong, institutionalized, systemic
> assertion of badness.

To have politics overtake your personal sphere is no one's choice. It is, for Michael quite literally, to be imprisoned. As we know, prison does not begin with breaking the law, or going to court, but can start already with, say, being black, or poor. It's a desperate and in many ways hopeless situation, but not one within which there is no space for ambivalence to produce cracks. That's what "Doing Time" is about. And we do have a choice, when it comes to where we address our exasperation. To institute such a regime of right and wrong in art discourse, for instance, strikes me as a thoroughly bad idea.

*

On the subject of identity, Michael takes a strikingly unfashionable position. Inspired by his biology class, he calls identity features "secondary phenotypes." "I think a lot of people invest excessive amounts of energy in expressing their identity. Truthfully, no one really cares if you're black or gay or whatever." This is quite the statement coming from a Latino man who's spent ten years of his life in the Sensitive Needs Yard to avoid homophobic violence.

110

We still joke about it, though. "OH GOD." I wrote to him in April, "There is this couple sitting next to me at the airport playing Pictionary, and he will just not stop lecturing her. He is SO annoying. Straight men are so often like this: know-it-alls. And they rely so much for their sense of self on being able to teach people around them all the time. Teach them about fucking Pictionary."

"You were spot on," he replied, "about how straight guys love to talk. I think it's the most obnoxious thing in the world when people talk about shit they have no clue about. You see it a lot in jail. Stupid people wasting their time talking about nothing."

I guess that's what it's about: trying not to talk shit, trying to have a clue.

This is not easy: Peter Voss-Knude spent several years building relations with the soldiers before I saw him barefoot at the grand piano. Naeem Mohaiemen, Chloë Bass and Peter Custers, too, invested many hours and long days in a complicated conversation. "Although we were careful," wrote Bass, "I can easily say I wish we had been more so."

"Are you gay?" I asked Michael in my first letter to him in the summer of 2015. "I don't know if that means anything."

"No one really cares" went his eventual reply.

But, like a child needs its transitional object, still, I believe, it's a place to start.

CHAPTER 4
Skin Hunger

RYAN

Ryan was on holiday in Europe when, during his three-day visit to Berlin, he asked me if I wanted to get "spit-roasted." It was a Wednesday night in December 2017, and while he was at everyone's favorite watering hole Möbel Olfe with a friend, I spent the evening on Grindr, drinking tea in the kitchen with Alessio and bemoaning the bleak conditions for intimacy in the city. When I went to bed around two, Ryan sent me a couple of pictures of himself, shirtless in some fabulous tropical destination or other.

 —You look sweet, I said.

 —Thanks, Pix?

 I sent pix.

 —Sexy. Horny?

 —Sure, I said.

 —Good, he said, and then the question of the spit-roast.

 This happened during a week when I'd been relaying to everyone I came into contact with the concept of "skin hunger"—a pathologized condition rampant among the elderly in the Danish care system from which I also suffer.

 —Let's say my skin is more hungry than my orifices, I said, if that makes sense.

 —Not really, he replied, you want a facial?

 —I just want someone to lie with.

 —Where are you located, he said, can you host?

This is how it began: my new project. A series of short stories about my sexual entanglements. The collection would be called *Skin Hunger*, and each story would bear the name of a man that I had met, using that encounter to thematize some issue pertinent to contemporary life.

 Let's take Ryan as an example: he is one of those people who moves money around for Goldman Sachs. Wow. One of those people. I had said this to Alessio earlier that evening, when I exchanged WhatsApps with a young man from Syria:

"it feels like I'm really *in our time*": that time when Angela Merkel said "Wir schaffen das" and every other person dancing to J-Lo on Saturday night at SchwuZ was a young man from Syria; that time someone from Goldman Sachs, the company that bought Denmark's oil reserves from the state, put his hand on my throat and I looked him in the eye so as to let him know not to stop.

Ryan's parents live in Cape Cod. His one-bedroom in Midtown Manhattan is a steal, he told me, though he partakes in the hefty downtown gay scene only half-heartedly. He's twenty-nine-years old.

It transpired that Ryan can't sleep without a heavy dose of prescription sleep medication. It's been like that for three years. When he closes his eyes the thoughts just race through his mind. "Is this a big problem for people who work in finance?" I asked. "For the people who have a conscience," he said, "yes."

A few years ago, I heard about someone who interned with a bank in Canary Wharf, London's international banking district. A taxi took him from the office to his flat in the middle of the night—I imagine one of those new-builds along the Docklands Light Railway—and waited for him to wash before bringing him back to work. This was the routine. One night, it took too long and the taxi driver became suspicious. He went upstairs to find the intern had passed out from exhaustion and drowned in the shower.

And so, the story about Ryan became a story about neoliberalism, about how we might encounter ruling ideology in bars, in our beds, personified. That sweet broad-faced man— so white and clean, like one of those screens that softly redirects the light onto the subject of a photoshoot—a duffle coat with an immaculate torso underneath: Ryan became "one of those people."

"I don't really feel guilty about the job," he told me, "I just wonder about my future, what's going to happen, if any of it makes a difference. I just move money around. Still, I

116

couldn't do what you do: freelance, the uncertainty would make me crazy."

"I do worry about it," I told him, "but at least I sleep at night."

"Eight hours through?"

"Sometimes even 12."

COOPER

"This is the danger," Tank said to me—I had started reading the short stories aloud to anyone who would listen—"that you become seduced by your own voice and forget about the people."

"You gotta leave it," went her advice, as she's so often advised me on matters of love, "before you become too invested. You have to stop writing."

By then I had written another story about someone named Cooper, who had stumbled into my bed drunk with rapid assertive movements—a "choreographed fall," I called it—thinking it was my flatmate's. Not believing my luck, a cost-benefit analysis raced through my mind: "Do I insist on waking him up and returning him to Alessio's bedroom? What if I don't? Since life has dealt me this card (who has dealt me this card?) should I use it? That is, should I touch him?" I did touch him. This is an aspect of the story that I would since play down. On his back, arms over his head, the covers pushed off, he looked hot. I traced his armpits, his lightly hairy chest, the protruding abs; embarrassingly, I spooned him until he rolled over onto his side, rejecting me. I left him alone.

John Updike's 1968 novel *Couples* lay next to me on the mattress. Since Valentine's Day I'd been listening to Ester Perel's podcast about couple's therapy, I'd been thinking about Chris, and how we fucked it up, how used I had become to carrying that wound, no longer as wound but as lack of

certain things, like complication, frustration, as well as an opportunity to read more novels. Cooper falling into my barren nest fit perfectly with the narrative debris already there.

Resting my head on the palm of my hand, at 10 o'clock, free of the pathetic hesitations of the night, smile awry, I asked him:

"So, are you ready to tell me who you are now?"

He woke up instantly, and looked around the room.

"Do you even know where you are? If you say Friedrichshain you're in trouble."

He had some questions too: "Who is your flatmate? Is he nice?"

"Medium height, dark hair, charming—you did well."

"I have a boyfriend," he said. "Fuck. Probably good that I came in here."

This is how I felt: Mrs. Dalloway taking a nap in the afternoon. She sleeps in a room by herself at the top of the house in a single bed. "Virginity clung to her like a sheet," Woolf wrote in 1925, a line that always stuck with me. I said to Cooper: "So that's why you came into my bed! A safe and sexless destination." We laughed though I was only half-joking.

Then life—or whoever—dealt the story another ace. We turned out to have graduated from the same art school and in the same year. I was editing the school journal and had rejected Cooper's proposal. He'd since grown a beard and cut his hair short, a miraculous kind of makeover available to some of the male sex that makes them instantly impossible to recognize.

I pulled the publication out. I hadn't looked at it for years. We were both a bit shocked at being confronted with this weird fragment of our past. "We wanted everything to be political," I told him, "like, if it isn't that, then why at all? An unreasonable thing to ask of culture, it strikes me now." It had been the last great gasp of that logic for me, and somehow for Cooper too.

And so our serendipitous meeting spawned a critique of the political paradigm within which that journal was

produced. The story became serious, and with that: valuable. Work. It contained analysis and description that, as someone whose livelihood is writing cultural criticism, I could not necessarily afford to throw away.

At the same time, it seemed that the critical value of Cooper's story, when it came to writing it down, could not be disentangled from its more embodied and far too tender aspects. The reference to Woolf, the musty joy I took in making a caricature of my own chastity, and using Cooper as a spotlight for my loneliness—it was both too embarrassing to share with its subject, and too irresistible to give up. When Tank said "you gotta leave it," what she meant was, "there's no way you can publish this." But couldn't I have made this up? Who says I haven't?

In the autumn of 2017, I toured a lecture called "Using People" in which I parse the problematics of employing experiences, particularly those of others, as raw material in art. The occasion was the publication of a Swedish translation of an excerpt from "Doing Time" in the literary journal *Glänta*. "Doing Time" was a product of the same mindset that had produced the very political school journal two years earlier. And as such, in its aftermath, I'd become fixated upon this issue: What does it mean to use people in the first place?

Not the prison-industrial complex, not the philosophy of freedom and difference and in- or outside—what I had intended as the real subjects of that work—but: *Can you?* Gothenburg, Zurich, Berlin, Stockholm, I toured this anxiety: *Am I even allowed to write this?*

In the lecture I argued that, though it's no easy task—yes. But in the Q & A I'd always say, anyway, that I wouldn't do it again. I mean: next time, it has to be less complicated. Next time less exhausting. Writing is exhausting enough without ethical dilemmas trailing unresolved in its wake.

Yet, here I am again, too deep in Cooper and Ryan and the rest, not taking my friend's advice, not leaving it alone, but asking myself: Why can't I just write fiction?

ALEX

So I kept not leaving it alone. As winter turned to spring, I walked to the top floor of a Kreuzberg apartment building carrying groceries and Bordeaux to find my stories beginning to thematize themselves, to strike the core of what "Skin Hunger" had thus far only skirted around: what it means to be present, together or alone, and how presence is reproduced in art.

Alex is a 23-year-old Internet performance artist via some elite New England liberal arts college, who happened to grow up in the house next to Gwyneth Paltrow in Los Angeles. After a failed attempt, on my part, at having a nice time at Berghain with him three weeks before, Alex recovering from the flu seemed the perfect time for us to finally have dinner; him semi-sedated, me in my element.

It started out promising. We began texting on Facebook Messenger after meeting at Möbel Olfe about a month prior, and Alex immediately changed the color scheme and the default emoji. It was like decorating a room: light purple, more Miami than Provence, and a bright yellow sun with a halo of pointed teeth. It became more intimate. Gave me the feeling that he had invested something in "us," an admittedly extremely tentative "us." Really just a: "we seem to get along."

Intimacy, as it would begin to dawn on me, means something very different to Alex, looks very different to Alex. I mean: if we were to have a group chat, the color of the speech bubbles would revert to blue. I mean: I could never (and have never) really touch(ed) him, except, weirdly, awkwardly, the knots of his spine when he was stretching in Berghain's endless toilet queue.

What's weird about Alex is that there is no difference between how he speaks and how he texts. His tone of voice is like graphic design, it bears no relation to what is said. That

is, the physical reality of his body is subordinate to a matrix of mediated presences of which the body is just one.

Let me unpack: When you are in front of a screen—regardless of who or how many people you communicate with—your body is physically alone. And this is the reason for its subordinance, because you don't *feel* alone; rather, these very mediated interactions constitute what you have come to know as togetherness: being non-alone. It is not a devaluation of togetherness but its icon.

That night in Kreuzberg, when I went to his flat in the most physical of ways, a visitor from the twentieth century with my Dijon mustard and that goddamn Bordeaux, which I would empty on my own, I felt like we were more non-alone than together. That is: I couldn't reach him. Our togetherness was moderated by a teak desk that Alex used to guard his personal space, and the intense conversation was of the sort that one might get dragged into unexpectedly online. (There is an intensity to this "non-"; it is not negation but exacerbation.) Each message carries the same weight, because there is no intonation. Every lilac speech bubble exists on a plane of total equivalence. Because no feature of analog presence has installed a minimum of stability, any utterance has the power to change everything, while simultaneously leaving all that is tangibly there as is.

And by one such utterance Alex's and my conversation was derailed: "It's not very funny," he said, "when people reiterate your reads instead of making their own. I've had enough," he said, "of your boring niceness. I had to call it out."

My first thought: What's a "read"? Then: it's true. Not being able to understand Alex through his lack of intonation, of gesture, I'd found myself repeating his words back to him rather than protesting, but this time *with feeling*. See, my speech is the diametric opposite to Alex's digital deadpan. Rather a classical composition, many elements are there to offer atmosphere and depth to whatever's in the Golden Ratio. But, hey, if Alex's presence hadn't been digitized to

begin with, there would have been something in my Golden Ratio. And besides: How dare he force all the details out of the shadows? I smelt blood, but something else as well. A story. Gold.

The derailment produced an acute realness between us—hyper-realness?—a sociability different from more typical kinds in the same way that art is different from the rest of life. Like art plays with its mediation to derail the viewer's experience of space or surface, so Alex had broken our joint contract with sheer presence. At the time of our dinner that Friday, I had not yet seen Alex perform live—that is, interact with his screen in front of an audience—but I had seen other of his works on his website: the wig, the cap, the abs, the Valley Girl speak are all regular features. The videos are well written, poorly produced (I assume, purposefully so), and share with real-life Alex this atonal flippancy hovering between sarcasm and plain nonsense. As the distinction between Alex and his art became blurry, I wondered if my writing about our encounter would also amount to a kind of art criticism. The post-Internet years had passed me by without me ever understanding what it was all about, but it seemed Alex might be my chance to make up for lost time. Of course, I couldn't have put it like this to him then because I, as ever, remain the humble servant to smooth sociability; because freelancing for both love and money, the most important thing for me is to generate and sustain.

But also: as the single person looking for love self-annihilates as they shower their candidate in hopeful projections, so the writer must become one with their surroundings while they scout for their hook. Does this comparison work? I mean, since working as an art critic, I have, paradoxically, had to become less critical and more patient, more open. I come into knowledge through ekphrasis (description). It is my job to be on the side of the work, to help it exist in the world. Looking back on it now, perhaps my compliance with Alex reveals that even if I hadn't understood him as such at

the time, I already hovered carefully around him like the critic around the art work. With my smooth conversation I was treading water, waiting for him to reveal himself. "I had to call it out," he told me.

In a *Bookforum* review of Rachel Cusk's 2018 novel *Kudos*, Sarah Nicole Prickett describes the narrator, Faye, a writer, as "a pair of eyes in a jar":

> Faye appears contre-jour—"against the day(light)"— as she would in a documentary, an anonymous source. Mostly she listens while other people tell their stories. She speaks as little as possible, with the cagey, barely-here affect of someone in a witness-protection program. When asked what kinds of things she writes, she says it's hard to explain. I would call it selfless autobiography, which doesn't make sense.

It doesn't make sense because it's not exactly true—this is what makes Cusk's trilogy so intriguing. Faye is manipulative and judgmental, her portraits do not aim at truth but narrative cohesion. As such, the writer of fiction is not so different from the art critic: whether describing a character or an art work, both write mostly about themselves.

The artist plays the same game. But when Alex and I were not really together, not really alone, but non-alone, it was for very different reasons. From Alex, I was looking to spin a fiction, but to Alex, reality doesn't exist. As we began to patch up our derailment, and I learned about Alex's online *Bildungsreise*, I came to understand what this really meant. Alex's art, in his own words, is about what he owes the Internet; what all those hours invested yielded in return. The recognition of nothing less than a different way of existing; of speaking without sound, of being simultaneously never and always "there"; never and always alone.

From witnessing Alex IRL I finally understood this—the guiding paradigm of the post-Internet—not as a theoretical

provocation but as simple description: no difference between URL and IRL, no difference between representation and presence, screen and physicality, being and signification. What happens to fiction when reality is always already mediated? Alex doesn't care about the real world. He wanted me to read him like an art work, so I did.

When Alex was ten years old he won an award among thousands of users for making the best room on a massive multi-player online game called Disney Magic Kingdom. This is probably where the Facebook Messenger decoration impulse came from. Conversation ran smoother once I gave up on participating, and let him just go on. After Disney, it was a chatroom game called Survivor, an online version of the popular reality TV show, where alliances and betrayals determine who gets to stay on the virtual island. A snake with a cute picture, Alex won again. He was the one who everybody liked, he told me, because he seemed innocent. The reality of the game was that there was no card he wouldn't play, it's just that innocence was his strongest one, and it worked.

His next avatar was on Cam2, a public webcam masturbation channel. "Having lived your online life, until then, rendered as a character or a still image, did your relationship to your body change as it appeared on the screen?" I asked him, feigning naivety.

Since the age of ten, Alex lived the scrawny kid's classic escape from the brutal world of real-life children into the virtual, devoting himself to one virtual identity after the other, parked for years in front of a screen in the house next to Gwyneth Paltrow's. This narrative was somewhat incongruent with the off-the-charts Herculean man, so immensely physically present, although seated at a safe distance from me. But Cam2 made it all come together: this body constructed as a way of winning yet another game. Like the prestigious *Lilo & Stitch*-hat Alex could afford for his avatar on Magic Kingdom, on this platform, ab-apparel was

the ultimate currency. And just as the sleight of his voice is detached from the words that it speaks, so his gorgeous torso is an image (on Cam2 decapitated), an isolated component that contributes to a whole in the same way that a desktop computer needs a keyboard.

I too have spent unending swathes of time on these types of cam websites, but never dared consider that time significant; it was too grim, somehow, too private and dark. The endeavor to privilege randomized cam life and its affective attachments, I think, is the strongest aspect of Alex's art. It reminds me of what the writer Josefine Klougart said when I interviewed her: "a writer's job is to place themselves, not above experiences in order to write about them, but to let themselves be led to a place where they dare realize the fact that these experiences are meaningful."

And what Travis Jeppesen wrote about Ryan Trecartin's 2007 film *I-Be Area* (a seminal precursor to the post-Internet turn): "our own physical containers can no longer contain us, if they ever did. *I-Be Area* is the drama of this failed containment, a literal and ritual purging of the frame. Don't tell me what something *is*; rather, *inhabit it.*"

This is almost exactly what Alex told me: Don't talk, be. Online, being and discourse take place in the same breath (the same push of the enter button). When Alex speaks (texts) that is the essence of his presence—completely irrespective of his body. When he is tired, an electric sigh takes him into a forward fold and I count the knots of his spine as they protrude through intelligent fabric. Conversely, my mindless chatter is the elevator music sound-tracking my being in the room. What I didn't know is that I may as well not have been. Music is a non-sequitur.

Where in Klougart's approach to writing you "lean toward language" to become part of its flow, in Trecartin, the "physical container" from which you would lean is, at best, leaking—you are already there: you *are* language. As such, it is clear why the Internet has made such rich material for

artists: the immersion that it offers is the always-already formal mediation of the self:

Simply by using you are naturally producing.

I almost wish I had met Alex on the Internet now in the same way as one would want to read a novel in its original language. Hearing his story was a kind of revelation as to where post-Internet art comes from: building the non-alone out of aloneness, that is, making a strength out of what might have been a weakness. For hours and hours, years and years. Perhaps, in Alex's case, what Jeppesen extrapolates from Trecartin's work holds. He writes: "If there is any true reality, then it is in the machinic nature of shifty becomings, the drive to escape the inescapable" ... what, existential solitude?

He had been yawning for two hours when finally I got up to leave. Write me a scathing review of the performance, he said, and publish it in *Frieze*. "They don't publish negative reviews," I said, sheepishly. Longing for the sun emoji intimacy of our lilac chatroom, I hugged his hard body and said goodbye.

SANDER

"I feel like I should tell you," Sander told me at the end of our weekend, "that I have a boyfriend." "You don't have to tell me that," I said, heart sinking, "you don't have to tell me anything." That's what makes this story different from the others: I felt crazy.

What makes this story different is that I didn't write it in order for it to eclipse reality, but to sustain it, to bear it, in some way, to hold reality to its promise.

Was it the sun at the canal that Sunday (the first of the year), too much fresh air, the compulsiveness of our meetings, his short-shorts, or was it those two shots of mezcal Enrico gave me at Peter Voss-Knude's opening that Friday when he

126

said "I'll introduce you to Alexander"? Enrico, a shaman with his elixir: "He's doing a documentary about a prison in Africa," he said, "this should interest you." The prison in Africa is what established from the beginning a need to be in the company of, to speak with, and not to stop: Alexander was in Berlin for the weekend and his friends call him Sander. We were in the back room of the gallery with Peter's big charcoal drawing of a military swimming pool when it emerged that Sander's project in Zambia is quite different from mine with Michael (in more than the obvious ways: Zambia, United States, film, writing), because he is not interested in the ethical question of what it means for him to produce work within a relational framework characterized by such harsh difference; he feels no need to justify it. "It's documentary," he said, "appropriation is what it's all about." Sander doesn't have any guilt.

But he did have to pee—that surge of vernissage beers both the reason for and the end of every conversation. The toilet was right there in the corner of the room and he said, "wait here, I want to continue our talk," and this where I think I might have already gone crazy, because I didn't: I wasn't really there, you see. Not being there is the kneepads I wear to avoid scratches. I was on the private view-train, what Maria calls the dick-wave, not because you get dick, but because you become one. You graduate to this stage when you've been single long enough and intimacy becomes such an unlikely possibility that your strongest card is your agility. So I went to get another beer—I was out of there.

What's weird about Sander is that he was actually there, I mean present not only factually, but in an abstract sense, too. Despite my leaving (and his boyfriend) there was a recalcitrance to his being there. I had been thinking too much about what it means to be present since Alex suggested that I wasn't, and since I wrote down that I don't think that he was either. Or that presence means a lot of different things: from my elevator-music politeness to his uploaded deadpan. This is relative also to the dick-wave, the hurry-currency,

kneepad strategies. To snap out of non-being you have to flip a certain switch and let the wave crash over you. Stop and assess the damage.

Where Alex instigated our derailment by actively transgressing the rules of social decorum, with Sander, derailment was the premise for our togetherness: "Can you go for a drink?" he asked late on Saturday night. Is he crazy? My mother and my sister were visiting from Denmark for the weekend. Everything else—my life, essentially—was canceled. I said yes. It was so obvious that something was out of the ordinary already; that we had derailed our respective flows. The embarrassment of saying goodbye for an hour, yet not leaving—that is what it means to go out of one's way. For people to witness the failure of your agility, to see your currency plummet.

"It's not good enough," he kept telling me, "you can't leave now, you have to give me more." He understood how to work my guilt, and insisted on my obligation to provide him with some kind of solution to the problem of this Africa prison project, like: What is he going to do? How can he show up there with his eyes, and his jawline, and his short-shorts— quite gorgeous—what will he say? What a terrible circumstance? How lucky I am (with my legs and my eyes) not to be like fish in a barrel in these people's shoes?

With contrived earnestness I took on this task as if there could be an answer, as if that was why I came and why I was still there. I told him about my lecture, how it explores the ethics of using people to make art by accumulating instances in which it has happened with greater or lesser success only to come to the conclusion that there is no hard and fast rule— it's never neat. But this endless awareness of the complexity of things must always be seen in relation to the fact that I did it anyway (all the people that I mention—artists, writers— did it anyway), and that seeing an issue from every which angle only produces depth, not progression, not movement. This "anyway" is the chorus of "Doing Time," the reason it exists. In the end, you have to be brave. Between Nietzsche's

128

ethical being, his bad air, and the first rule of prison correspondence that says, "don't promise anything you can't keep," and what Max Frisch wrote to Paul Celan, "I cannot leave you without an answer," I wrote to Michael in prison: "The only promise I can make is that I will continue to correspond." What you owe to a dynamic is not being right but owning whatever position you end up taking—even if it's opting out.

"Tomorrow between 16 and 19 it is ethically okay if we hung out—without your mom, perhaps," Sander wrote to me at four a.m., not a question, but a statement, which leaves me not with the option to agree or disagree but to oblige or defy. "KOM," he wrote, all caps. And I did. We bought Desperados at Admiralbrücke and dangled our feet over the canal. The scene was exquisite, and the sun, I found out, brought out the colors in my eyes. Then he said the thing about the boyfriend, and I started to ramble: there was simply no filter anymore. "I've indulged in something with you and I don't know what to do other than name it." I was thinking again about what Josefine Klougart said about writing: about leaning toward language, daring to be led to a place where experiences become meaningful. The breaking of a dam and the outpour that follows is the babble of psychoanalysis, when it really begins. But that's when it ended: when Peter came by and we stopped talking about "us" (not a tentative us, but one exhilarated by the very absence of its realization), started being together in secret, our hands touching out of sight. We kissed as he "helped me across the fence," another excuse, and I left, out of breath.

After my friend, the artist Ellie Ga, read "Doing Time" and "Using People" she wrote me a long, thoughtful letter back. About the relationship between the two, she asked whether presenting the lecture as an epilogue would be "enough": "Because there is something so moving and vulnerable in the less rooted, more tossed about space of the work itself," she wrote, "you trying to

129

get your footing." By "enough" I suppose she meant to say that the fundamental trembling that runs through "Doing Time"—the feeling of having dived in at the deep end—and the odd decisiveness that characterizes the lecture, after all, may just be too incongruent. What Ellie described as "the tossed about space of the work itself," Peter called "a tone within the text that implies some sort of guilt over even wanting to approach Michael in the first place." The beauty of that text is its pain (my worry), and the reason for the difference between book and lecture is that I became tired of worrying.

If "Doing Time" is about negotiating alliance in spite of difference, and treading that unstable ground, Sander's work (and our being together inside his prism) is more like playing with repelling magnets: exploring an absence that has wedged its way in, in spite of sameness. In his short film *Carl & Niels* (2013), two twins, estranged from one another in the early stages of adulthood, are prompted by the director to meet back up in a film studio and attempt reconciliation, or at least some kind of renegotiation of togetherness. In one scene, after wrestling topless in artificial snow, one tells the other: "I feel so completely alone without you." Meaning: once, I was not alone, fundamentally. The soft tragedy of *Carl & Niels* (the beauty of Sander's film) is that they could have been the same—strong, happy, never alone—but they're not: sameness, like bliss, like love, can be lost. But the twins are smug, entitled even, *accustomed* to the privilege of belonging with another human, so they squander it. They purposefully appear to hurt the other, to push them away. There'll be another sunset tomorrow, more intimacy, always, to fritter. And this is precisely the appeal: truly being there, but pushing being to its limit until it becomes instead the absence of something else.

What I like about Sander (and his films) is this sense of freedom, of self-assurance and conviction and not looking back. When he said "HVAD LAVER DU," when he said "KOM HER OVER," his caps expressed courage and emboldened

me to do the same: "come to Bar St. Jean" I wrote—and he did, isn't that crazy? On Sunday night he showed up to finish our business: to lean in toward one another as if we could not hear what the other was saying, to kiss, finally, not out of sight. I felt the stubble of his cheek against my face, the stubble of his legs under the satin shorts, felt maybe a little bit too much, because Sander pulled the breaks. Even now I don't understand what happened. "I'm not really here," he said. Disassociating? Guilt-tripping? In any case, a slippage of presence—tables turned. If I was ever *contre-jour*, at this point I was a deer in the headlights.

To my mind, Sander was speaking from the comfort of his relationship, where intimacy is not, as we say in Danish, a town in Russia—so distant and foreign as to be impossible— nor what he stands to gain, but what he is willing to gamble. Was the promise of closeness more thrilling to him than its realization?

And here is the limit to the creative drive behind these stories. Put simply: sex sells, but what it sells is not itself, but something else. Its byproduct—that is, the work—must be more valuable than the fulfilment of the desire that drove the process. The relation is a starting point, not a type of content, and certainly not an end in itself. I addressed this problem in "Doing Time" when I wrote to Michael:

```
You know how after you come, you suddenly feel
very different, very silly--the thing that
mattered just before, now belongs to a differ-
ent mindset entirely. I don't want our conver-
sation to depend on the whims of desire in that
way, or at least to ejaculate prematurely.
```

What makes this story different is that it no longer beats reality: that's to say, it's not even on a trajectory toward ejaculation, but already gone too far beyond it. I thought writing would satisfy my skin hunger and redeem the desired object,

131

but it turned out I was the one being fooled. Encouraged to dive in at the deep end (again) by holding Sander's hand, I now longed for my life vest. I'm Scarlett Johansson in *Match Point*, a mistress on a zero hour contract with no legal rights, alone and vulnerable to murder. "I'd rather be lucky than good," says her married lover before he shoots her dead, and Sander, like Carl and Niels, can also afford to play this game of chance. But my strongest card is my agility, remember, and the price of real presence is that there is no escape hatch. "I need you to say something before you leave," I said to Sander as my last request, a plea, almost like Paul Celan's, "to make me feel like I'm not crazy."

And like Ingeborg Bachmann and Max Frisch, the addressees of Celan's plea, Sander cannot leave me without an answer: "How about," he suggested, finally, "I wish I could stay?"

*

About a month later Sander was in Zambia, shooting the documentary. "I'm not so big on sticking to one genre," he wrote to me, "I like experimenting, playing with more than one at once." We were on WhatsApp. How much better would it have been if I had set this scene IRL, still by the canal in the sun when I heard about the boyfriend?

"What do you think about this," I asked, and sent him a quote from Janet Malcolm's *The Journalist and the Murderer*:

Where the fiction writer is the master of his own house, the nonfiction writer is a tenant, and he must leave the property as he found it. He may bring in his own furniture and arrange it as he likes (the so-called New Journalism is about rearranging furniture), and he may play his radio quietly. But he must not disturb the house's fundamental structure or tamper with any of its architectural features. The writer of nonfiction is under contract to the reader to limit himself to events that actually occurred.

132

—It sounds neat, he replied, but I am definitely no tenant. And I believe it is perfectly alright to make permanent marks, and leave the house in a better condition than when you arrived.

—But what if the story you find isn't reparative?

—You don't find a story, you make it. It becomes real when you dare speak it out loud, and you must have the courage to do that, otherwise it won't be possible for the cast to assume their roles. They're playing themselves.

—And what if the cast don't like the story you come up with?

—That happens quite often, but usually something interesting comes out of it. You have to appreciate the gifts of documentary-making—the things you weren't expecting.

—Building up a story intuitively, day by day, in this way, is not so different from fiction, I suggested, where the text also seems to have a life of its own: you react and respond to the images and structures that emerge out of it. The difference is the transparency—you have to let your cast know.

—Today I couldn't reach one of my cast members, like: he wasn't there. He's too smart in front of the camera, he gets all sensible and stiff. I need him to be dumber, more lively, more fun—he has this side, I've seen it. I don't know how to tell him this: I don't like it when you're smart. I think I will ask him some dumb questions. You should ask me some dumb questions.

—I know that so well, I replied, that is SO problematic. But OK, I'll ask you some dumb questions: How's your boyfriend? Is that a dumb question? I have another one: What is it that you think you're doing?

—Oh look at you go! When will I get another one of your bedtime stories? Maybe the one about the other Alexander?

—I'm working on a new one now, I told him, the ultimate, the greatest hits. I'm not sure yet how it will turn out.

CHAPTER 5
Love Lockdown

"You have to send it to Alex/Sander," Ida said, grinning wine-blue teeth, "and when you do, cc me in!" Alcohol is hard to come by in Sweden, but we had a box of red to ourselves in the teacher's quarters. The Biskops Arnö writing school is on an island in a forest a couple of hours north of Stockholm—a splendid and historical setting that tends to make people smoke and drink more. On the occasion of the annual Debutant Seminar hosted by the school, earlier that day I had given a talk called "Why I Can't Write Fiction"—a previous version of "Skin Hunger"—to a small audience of authors from around Scandinavia. It felt kind of crazy listing my sexual escapades and romantic disappointments to a room full of strangers. But in the context of a literary event, the confessional aspects quickly gave way to a conversation about style and composition. By the evening we were all telling stories about how our exes came out in fiction. Karl Ove Knausgård met his wife, the novelist Linda Boström, at the same seminar some twenty years earlier. He'd since published a pretty brutal portrait of her in *My Struggle*.

So there we were, in the middle of summer, steeped in auto-fiction's natural habitat and in red wine, when the name of the game I'd so long been playing finally lit up, like Casio font on a screen: everybody robs life, everybody hurts, no one can say for sure if it's worth it, but we all continue to do it anyway. Still it wasn't until two months later that I decided to accept Ida's challenge.

August, 2018

Dear Sander,

It was nice speaking with you while you were in Zambia. There's a strange boundarylessness to how you communicate that's very exciting, exhilarating even. The world in stronger

137

colors, kind of, more life. It was funny.
I think you thought so too.

As you know, I wrote this lecture for
the seminar in Sweden, "Why I Can't Write
Fiction." It is fiction, of course, that's
the point. I turn the intensity of us in
the same room into a piece in a puzzle, and
make it fit into the story. But I think it
is important for my methodology that I prac-
tice a certain level of transparency with
regard to my subjects--so, I am sending you
the monster. Then you have the option of
replying, or not.

But why this hesitation? From our last
phone call, I remember you telling me about
your safari. I imagine you in an open Jeep,
it has actually been pretty boring--the
animals are lazy; they don't "do" anything,
you said--but then, an unexpected highpoint
when the elephant takes a deep breath, flaps
its ears and signals attack. You rise to your
feet, and your boyfriend holds the camera.
"Say more fun things," you said when you didn't
want to get off the phone. Danger is funny
to you. You want more of that life-and-death
vibe. You do make television, after all.

But you know what they say about animals
is true: that they are more scared of you than
you are of them. And back in May, perhaps it
was me there, flapping my ears. I think I
needed a bit more distance from the Jeep; to
just scoot out of the frame of the picture.

But now I'm OK. Now the summer is over. Now
I send you the text--enough with the bullshit.

I look forward to seeing you again.

Sander's reply was predictable: "I wish you'd write about nothing but us, but that would be an unreasonable thing to ask [elephant emoji]." After Alex read the monster he asked if he could put some of the description on his homepage. The only thing more certain than an artist's self-loathing is their vanity. I love that about them. But of course I knew that Alex/Sander was not the real challenge to my methodology. And, sure, the two-month delay in sending the lecture after Biskops Arnö had something to do with gaining distance from my awkward relation, especially to the latter of the two, but more, actually, with getting something else out of the way first, delayed not for two months but two years. Michael still hadn't read the whole of "Doing Time."

*

In the two years that had passed since I finished the text in 2016, and during which I had tacitly decided not to publish it in its entirety and in English, I thought the reason was intellectual. That it was necessary first to solve a problem with identity politics by developing an argument for appropriation as the basis of all writing, from fiction to criticism, and understand better what it means to treat the world in that way. I thought my concern was with literature and with art—what it is possible (or understood as "allowed") to do in those fields—and to really appreciate that the authority that comes with authorship does not constitute some kind of brutality. Anyone who would choose not to go ahead with such a project, the philosopher Nina Power had advised me when I initially started writing "Doing Time" in 2015, would do so not in aid of the cause or the subject, but only to protect themselves. And thus convinced, I continued writing. But still I wanted to feel, deep in my soul, what Alex had replied when I sent him the lecture along with a note that read "Forgive me?": that my portrait was unforgivable, because there were no grounds for resentment, as he put it—nothing

139

to forgive. Being a writer with severe shyness of conflict is something of a catch-22.

But I *had* made those arguments. Again and again, I had stressed the importance of staying close to the work, of reading on the side of ambivalence, self-consciousness, performativity; insisted that readers and subjects have agency, that they are us and we are not so fragile either, and moralism, anyway, is its own kind of totalitarian regime. I had built a critical writing practice on the foundation of these ideas. I had even, as some of my harshest critics (my dearest friends) have said, over-identified with my aversion to a certain brand of PC-culture and identity politics, which I'd learned to see as anti-intellectual, paranoid, and unconstructive. "Why this?" Tank would ask when I phoned her, ranting, traversing the streets of Bergmannkiez or Prenzlauer Berg, walking across Berlin-Mitte, alone late at night, "why does this in particular occupy you so much? You agree with the political sentiment, why not just tolerate the excess, and focus on the real bad guys?"

This over-identification was partly to do with the fact that my arguments had done nothing to resolve the issue with "Doing Time." The text seemed to linger in my life, unpublished, representative of a stance I thought I hadn't taken, but actually had. No, the problem that was unresolved was not intellectual; not to do with a theory of appropriation, or some approximation of a rule for art making in general; something which would yield at a thorough consideration of what it even means to write. I knew that I was able to stand by the text. The problem was relational, emotional, personal. A text is not moral or necessarily ethical: it should not alleviate its reader of the responsibility of having to take an active stance. As such, it might even be more interesting if somehow "problematic," or at least compromised. A relationship is different. You know when something's not right. And that feeling, if you're not prepared to accept it, is not "interesting." It hollows you out.

What was I afraid of? I suppose that Michael would flap his ears at me, like I had done before, signal attack. That he would not feel flattered by the camera's lens taking aim, but rather hear in the release of the shutter the reloading of a gun. I thought about what Elizabeth Bishop had written to Robert Lowell, "art just isn't worth that much," and felt the same way: "Doing Time" couldn't possibly warrant its price tag.

My concern was not entirely unfounded. Michael had already flapped his ears. Six months before I wrote to Sander, I had sent Michael the first section of "Doing Time." It was much too late and too much time had passed. I wish I could say that it was all more blurry, that time had made circumstances stand out less piercingly, but this would be untrue. It was winter and I had sent Michael the first section of "Doing Time" and he had responded. "I regret to inform you," he wrote, "that I hold some reservations with some of my quotes that you have decided to insert into your essay." The formality of his phrasing was devastating. He felt that certain things were too private, he questioned whether I saw our correspondence as a means to an end. It felt like the end of the world.

Along with the chapter I had sent a note, apologizing for my tardiness, excusing and not excusing myself, admitting how nervous I had been about his reaction. That he was the only one who could pull the rug from under my efforts— "(a rug that is entirely yours to pull)," I wrote in parentheses. Less terrified, actually, about the rug and my efforts, Michael's letter inflamed a more serious, deeply human anxiety: that I had betrayed our friendship, that I had been wrong to write, that I had committed a violation, an act much conflated with violence itself. It was winter and it was dark and I left my dad's house to pace the dense Copenhagen suburb. I crossed the railway at two points; Sweden glimmered on the other side of the black hole of sea; I called Tank in a panic: "It's happened." The sort of thing you say when

141

borrowed time is up; when your shit boyfriend has finally run off with someone else, predictably younger and more beautiful, much like getting into something years ago and thinking, I'll deal with this later, surely later will be the time to deal. Of course there is no later—time is not a flow but a repetition; it doesn't heal, it hardens.

In the end, I edited out the bit he didn't like. There was conflict, naturally, but not total derailment. The quote that Michael took issue with was one in which he described how sexual and romantic relationships unfold within the prison scene. He didn't like my using it because he thought it was too explicit, too harsh; he hadn't been in a good place when he wrote it. It's true that there was anger in that letter that decomposed his language, some excess hurt that disfigured his grammar, and was quite uncharacteristic of him. Yet I had initially included it not for the drama but because, well, I understood. Looking back on our five years of correspondence, though at first so hinged on difference, it is actually heavily thematized by our mutual propensity for rollercoaster romance.

Two years ago I'd only read Bishop's hard take on the controversy around *The Dolphin*, and curiously not thought to consult the widely available writings of Elizabeth Hardwick, whose letters Lowell had used. His claim that they had separated "as good-naturedly as such things can be" is corroborated by a letter Hardwick wrote to the novelist Mary McCarthy, once she finally found out that Lowell was leaving her for another woman (an heir to the Guinness beer fortune, no less):

> I knew Cal had a girl and had been distressed for some time, but it was just this afternoon that I knew it was Caroline. I felt such relief I burst out laughing! I called him immediately at her house and he talked as if he were talking to me from his studio, for an hour,

laughing and joking and saying you are spending all your alimony on this call.

It was upon publication of *The Dolphin* that her good nature turned sour, and she confronted Lowell with feeling "near breakdown and also paranoid and frightened about what you may next have in store, such as madly using this letter." Much more than in love, the severity of Lowell's betrayal was lodged in his literature. To Bishop, Hardwick commented that the parts of the poems that relied on her letters seemed to her "inane, empty, unnecessary. I cannot understand how three years of work could have left so many fatuities, indiscretions, bad lines still there on the page"—an assessment quite different from Lowell's own that "the letters make the book," which I had also heard said about "Doing Time." As always, several things are true at once, or in succession, and the question of appropriation is not only an ethical one, but an aesthetic one, too. In my case, Michael's hurt and angry letter was potentially not just a problem for him but for the text as well.

Other critics have agreed that Lowell's use of the letters did not enhance the quality of the work, but actually numbed the complexity of Hardwick's original words. It is also worth noting that Hardwick did not share Bishop's distaste for the confessional. Geoffrey O'Brien describes *Sleepless Nights,* Hardwick's masterful novel first published in 1979, as

> A novel that seemed to declare the impossibility of separating itself from life, yet admittedly one "seeming to be true when all of it is not."... *Sleepless Nights* might be taken as an exploration of the problem of genre, the problem of distinguishing fiction from what is so coarsely described as nonfiction, except that the book is more like a demonstration that the problem is illusory.... Since to live is to make fiction, what need to disguise the world as another, alternative one?

Her problem, then, was not with using other people for literature as such, but with which parts of them you take, how, and for what reason. Hardwick only refers fleetingly to Lowell in her work. Her interest lay in life's more subtle characters, let's say. I read all of *Sleepless Nights* aloud to myself. As loud, in fact, as I possibly could, practically yelling, angrily, trying to push frustration over the edge into relief, catharsis. I was heartbroken at the time, but couldn't understand why, or refused to believe it. Love! But a sneering tone to Hardwick's prose helped me meet that emotion, and embody the occasional shittiness of life not as boundless and spectacular, but mundane *as well as* something else—beautiful, maybe, or simply what enables us to feel with others. Hardwick writes the world and its people from past the point, a shattered vase that somehow still holds. Not without empathy, but with a clarity and precision that has no need for sentimentality. Does it make sense that this is the most sentimental? To continue speaking so long after your voice has broken a tremble runs through it naturally, consistently. In Hardwick, what this voice tells us is that the object survives.

In *Sleepless Nights*, she reflects openly about what it means to fictionalize the people around her, "that is to wonder what I would be forgiven for remembering or imagining. What do those of my flesh and blood deem suitable, not a betrayal? Why didn't you change your name? Then you could make up anything you like, without it seeming to be true when all of it is not. I do not know the answer."

My response to Michael was also infused with the allure of fiction. "This does not pretend to be an adequate representation of you," I wrote to him, "the Michael on the page is different from the one I know." As with any piece of writing it is mostly about the person who writes it. "Do you want me to change your name? Let me know if you do?" I wrote these things to him. There were times when I wish I'd changed Michael's name, changed all their names, or every other name. What would that mean? Can fiction be

an escape clause for accountability? Does fiction not answer to anyone?

Next time, it has to be less complicated, I had said at Biskops Arnö, next time less exhausting. After I gave that lecture and before I shared it with Sander, I sent off another letter to Michael with the remaining three sections of "Doing Time." It had just become possible to send PDFs via Jmail, so I didn't have to paste the text into the letter itself, like I had had to do earlier, and which, looking back, had been a kind of excuse for not sending it all at once. I saved the file on my computer as "To Michael (finally)." He soon wrote back that he'd read the text and liked it. He felt seen and quoted this line as especially accurate: "The past extends itself into the present from a certain point, and the col-lective inscribes itself onto individual bodies." He appreciated the reference to Nietzsche, the part about being able to keep your promises, and being able to say no. I was happy.

It wasn't directly related, but a few months later, I stopped responding to Michael's letters. Life got in the way. I also stopped thinking about "Doing Time"; stopped giving lectures about it, certainly had long abandoned the idea of publishing it. Like I'd said in Sweden, I was exhausted. But how do you know when something is over? How much do you owe to someone?

The only promise I can make,
the only obviousness I can offer,
is that—beyond myself (my writing) and beyond differ-
ence—I will continue to correspond.

I wrote that in 2016. And what I meant by it, following the letters of Bachmann and Frisch, was that, while it is not rea-sonable to demand someone always be in agreement, it is not only reasonable but politically and philosophically genera-tive to *remain*; to stay, as Donna Haraway put it, with the

trouble. And sure, in its wider interpretation, what I wrote holds. But I also wrote that doing time doesn't make sense as a concept if the time in question is de facto indeterminate. So what about in the context of a relation between two people? Continue to correspond for how long? There's something hysterical about promising forever, something masochistic, even, that assumes a debt that can never be repaid—a debt for what, exactly?—and that the relationship of self to other will be stable and unchanging.

It's also very romantic. "From now until forever / That's how long I'll be true." This kind of temporality features heavily in the early music of Britney Spears. She was sixteen at the time, a whole life ahead of her. In "I'll Never Stop Loving You" she cites the day "when the world stops turning and stars fall from the sky." Michael and I stopped corresponding at a time when both our hearts were being pummeled. When I say that life got in the way, I guess that is what I mean. "Perhaps I should have read your last letter more carefully back then," I finally wrote to him a year and a half later, "I might have learned something, I might have spared myself some pain."

But one is never permanently or only a victim. In some of Hardwick's letters there is desperation, in others total detachment, levity, cool. There is something almost perverse in the popular insistence that "the other" will be outraged or aggrieved by their representation; in certain respects this has a kind of inbuilt narcissism, because it suggests that a person can be broken or made by whoever is doing the representing. Time inside prison might feel like an ocean without waves—what would happen to the tide if the world stopped turning, if the stars fell from the sky?—but even though Michael looked out onto such an ocean for a time, he still had a view of the horizon. Twelve years is a long time, but it's not forever. When I got back in touch with Michael to discuss publishing this book, it was with pages and pages of hand-wringing anxiety. He replied with enthusiasm, not

146

about the book, but much bigger things. He's due for release very soon, he wrote—in fact, between me writing this sentence and it going to print, he's out, a whole life ahead of him.

Along with this extraordinary piece of news was a reflection on the nature of containment. "I was contained long before I was incarcerated," he wrote, "by addiction, self-doubt, and heartache." *Heartache*—what a thing to say: "what I've learned is that if we let our emotions guide our actions, sometimes it could be catastrophic." A broken heart makes a prison of the world. He's right. For years I've lost myself at every collision with love, every "seizure of optimism," as Hardwick wrote about an old friend, one "fatal rush into the future" after another. "Can you stop using metaphors," said the accumulated voice of every guy I've ever died over, "I don't understand what you mean." But Michael understood. On this matter, we were in total correspondence. One night, in another love lockdown, I bought an extra rare steak and ate it outside in the rain. The waiter asked me to come inside, but I said no. My whole life is a metaphor and I'm trapped inside it: drops falling into my large glass of red; a wet cigarette on Torstrasse.

Perhaps for this reason, I developed an eager fascination with Hannah Arendt. "It still seems unbelievable that I could achieve both a great love and a sense of identity with my own person," she wrote to her husband Heinrich Blücher in 1937. "And yet I achieved the one only since I also have the other. I also now finally know what happiness is." At an exhibition in Berlin I saw her fur coat and her silver cigarette case. I saw her erect on a rock in Cape Cod, hands at her waist, smile awry, bathrobe fluttering behind her. Arendt loved without disintegrating. Imagine that!

But then, she never seemed carried away by any kind of emotional impulse. *Eichmann in Jerusalem*, her book about the trial of Adolf Eichmann, the prominent Nazi captured in Argentina and brought to the stand in Israel, has not ceased

being provocative since it was published in 1963. But not, like Lowell's *The Dolphin*, because Arendt brought too much of her own life, or the emotional lives of named others, to bear on the work, but because she didn't. She was a German Jew who fled from Nazi Germany yet seemed to have no sentimental attachment to the Holocaust. She did not report from Eichmann's trial as a Jew, but as an adamantly disembodied mind. The collapse of civilization that the war had amounted to left Arendt with little patience for any and every *Weltanschauung*, Amos Elon writes in the introduction to the 2006 Penguin edition: "[she] subscribed to no isms and mistrusted sweeping theories." As such, she was not prepared to demonize Eichmann in simple terms, nor to shy away from pointing out the various hypocrisies of the new Israeli state. Eichmann, observed Arendt, was characterized above all by a kind of brainlessness, an unbelievable banality, that led to her famous conclusion that "Evil comes from a failure to think." Arendt did not only find this failure in the Nazis, but in the lack of dignity, the sentimental overtones, of the trial, as well as the tendency it represented to substitute a more genuine reckoning with the past for high-pitched spectacles. Toward the end of her report she digresses into a biting critique of German guilt:

> Those young German men and women who every once in a while—on the occasion of all the *Diary of Anne Frank* hubbub and of the Eichmann trial—treat us to hysterical outbreaks of guilt feelings are not staggering under the burden of the past, their fathers' guilt; rather, they are trying to escape from the pressure of very present and actual problems into a cheap sentimentality.

She really said it: sometimes "checking your privilege" is just plain teary-eyed navel-gazing. Perhaps "Doing Time" is underscored by a measure of this type of guilt, or so Peter Voss-Knude, the artist and friend about whose work I'd

written in "Using People," once suggested. And how truly pathetic everything is today, or perhaps always has been, in comparison to Arendt's unencumbered devotion to thought and to reason. From Knausgård to Trump and all of Twitter, the world is sorely lacking in dignity. But even then, the backlash against Arendt was fierce. In today's terms she was canceled; Lionel Abel wrote that she had made Eichmann "aesthetically palatable, while his victims are aesthetically repulsive." One newspaper called her a "Self-hating Jewess," another asked (about the author of *The Origins of Totalitarianism,* no less), "Is she a Nazi?" But, as Elon writes, the problem was less with what she said, than how she said it:

> At times her style was brash and insolent, the tone professorial and imperious. She took a certain pleasure in paradox and her sarcasm seemed out of place in a discussion of the Holocaust. Arendt posed the true moral issue but obscured it with needless irony.... Too often she claimed a monopoly on "objectivity" and truth, not just truth but repeatedly "the whole truth."

In short, "she overdid it." Though Arendt defended her work staunchly in the epilogue, in private (like Hardwick) she wrote to Mary McCarthy: "You were the only reader to understand what otherwise I have never admitted, namely, that I wrote this book in a curious state of euphoria." In spite of her apparent emotional detachment from her subject, Elon adds, "*Eichmann in Jerusalem* was an intensely personal work. The writing helped give her relief from a heavy burden. As she wrote McCarthy, it was a 'cure posterior,' the delayed cure of a pain that weighed upon her as a Jew, a former Zionist, and a former German."

The morning after my steak in the rain is when I started shouting aloud *Sleepless Nights*, pushing frustration over the edge into catharsis—a curious state of euphoria. I'd let myself plunge head first into tristesse, but it was picturesque,

149

cinematic, poetic; that is, close to fiction, or to art. And art, when it's good, makes a fine line between the happiest times and the saddest, the most detached or objective, and the least, simply for the reason that we take pleasure in its existence regardless. Any creative process might function like a cure, though only more or less posterior—sometimes even for the wound inflicted by that process itself, so immediate as to be almost simultaneous.

Perhaps with *Eichmann in Jerusalem* Arendt did not betray a cause so much as a genre. There was an excess of energy in her "report," like the anger I edited out of Michael's letter, or my bloody steak—energy and potential for release. That's what made it both brilliant and destructive, and why we are still talking about it today. What does that say about art in relation to the license it has to "use people"? And of emotional excess as its raw material? What provoked me about Sander was that he believed he could use his art to do good. To leave the rented apartment in a better condition than he found it, as he put it. To gamble without risk. But there's no release there, only more effort—at most *relief* at simply managing to steer clear of badness, for now. "What I've learned," wrote Michael, "is that if we let our emotions guide our actions, sometimes it could be catastrophic." My question is: To what extent is it possible to avoid catastrophe? Can reason be isolated? And is that even desirable? Catastrophe originally referred to a reversal of what is expected, especially with regards to the turning point in a drama, or the winding up of a plot. What's a story without surprises?

The energy I'm describing here might also be named the eros effect. What George Katsiaficas argues was the undercurrent of May 68. It runs throughout Jean Genet's *Prisoner of Love,* and in Manuel Puig's *The Kiss of the Spider Woman* it makes Molina run into a rain of bullets. We might consider what would have been lost if these people, writers, characters had not exposed themselves, if they'd stayed in the trenches, or stayed in the lane. Like Diane Arbus asked:

150

Would it have been better to look away? I don't think that even Molina, shot dead, would have any regrets. According to Katsiaficas, the eros effect allows us not only to imagine a new way of life and a different social reality, but to live—however briefly—according to those transformed norms. Reason as we know it is suspended, dignity superfluous. Everything is pure purpose. But love is also an excess, its power volatile. You hurl yourself at love like into a dark lake, not knowing whether you're out of your depth, and for that moment not giving much of a shit either. The price of such fearlessness is its transience, that is, when you come down from the high it's with a hangover. For writers too.

In Arendt's "curious state" we also find a measure of eros effect. Emotions rerouted from elsewhere, confrontations delayed, passion left over. If even the highest expression of reason is actually powered by eros, this would suggest that no writing can exist without it—only eros surfaces in different ways, and may not always appear sentimental. In a documentary from 2017 about the writer Joan Didion, her nephew Griffin Dunne asks her about her famous portrait of the Haight-Ashbury hippie scene in the late 1960s, *Slouching Towards Bethlehem*. "How was it for you as a mother," he asked, a misguided appeal to her maternal instincts, "to see a little girl, 5-6 years old, about the same age as your daughter, high as a kite on acid?" "Let me tell you," she said, pausing for a breath, "it was *gold*. You live for moments like that, if you're doing a piece. Good or bad." Here Didion too was brought to some curious state beyond morality, beyond her own motherhood, and, though ostensibly only for the sake of the piece, it's a rush worth life itself. Likewise, Susan Sontag, with her disappointment with the "cooption of the idea of revolution in art," and Janet Malcolm, who advocated for leaving the rental as she found it, yet endured years of legal battles over her writing, are also examples of this: writers whose passion is no less essential for their attachment to reason, and for whom "reason" can be viewed almost like role

151

play, a way to act out their passions, to channel them through a performance of control. This performance, as was noted at my first lecture in Gothenburg, acts both as a structure for passion and a transformation of it into something else—that is, some kind of art. That "poetry should never be afraid"— that pompous adage I heard a few years back—does not mean that form is an escape clause for accountability, but merely that being a writer is a tough job that demands constant collisions with the world and its people.

Still we might ask of Arendt, as Elon does, "Would she have shocked her readers less had she registered doubt instead of attacking?" Or is there a point when the eros effect is simply too overpowering to be channeled through form, and even a performance of doubt would push you into despair? In such an instance you might just dig your nails all the more fervently into certainty. I once wrote to Michael that I didn't want our correspondence to depend on "the whims of desire," because desire, while entirely self-assured, is a type of energy always threatened by depletion. This was regarding a potential turn toward eroticism between us (the "strophe" of catastrophe means turning). The problem with eroticism is that you steer toward an end without thought for what comes after. The problem with being in love—or any emotion run amok—is that you allow yourself a certainty that is not rooted in what is there but in what you think might be, whether out of hope of paranoia. But where the former invites bonding with others, the latter, as Eve Kosofsky Sedgwick has argued about the propensity in identity politics for "paranoid readings," functions rather as bondage: a masochistic narrowing of the world into a cul-de-sac.

To Arendt, judging and acting are closely linked; if you say to yourself "Who am I to judge?" doubt turns to despair, and you are already lost. We need some certainty to start us into action, even if sometimes false, or misguided. Otherwise things don't happen, like books or friendships, conflicts and

their resolutions. That's why a certain "anyway" is the chorus of "Doing Time." I wrote it despite and because of the moral tangle it would place me in, and although I had no answer to the question "Who am I to write this?" Hardwick, like Ingeborg Bachmann, said this too: "I do not know the answer." A "perhaps" runs through all of *Sleepless Nights*, and in that "perhaps," O'Brien comments, is the whole art of Hardwick's novel. Adding "perhaps" to "anyway" might just marry doubt with action, and rephrase interpellation as a question: not "Hey you!" but "Who's there?" I think so.

<center>*</center>

Arendt's concept of banality has much to do with language use: a reliance on stock phrases, a thoughtless inheritance of dead metaphors, a lack of imagination. As such, the antidote to banality, the sophistication of that "perhaps," might also be found in language. Five years ago, Michael made a similar point when he rephrased my question:

> Can someone be in unison with another person who is far away? I think if two people are able to depict their experiences in their lives to each other in a skillful way, enough to keep each other intrigued, then yes, emphatically.

What mattered to Michael was my attention to him through language, the effort I made to communicate in "intriguing" ways: expressing ambiguity rather than a false sense of certainty. At least I can say as much about what has made Michael's letters so valuable to me.

The contemporary chase after certainty, a stable moral code, is very hostile to literature. Both because its tunnel vision does not allow for poetic attachments, and because its underlying dialectic is negative, quasi-Adornian, if you will. That's why this project—a literary one—has found nothing

<center>153</center>

in the way of a stable code. My desire for some kind of guarantee that I had acted without fault, in the most straightforward sense, almost resulted in "Doing Time" and the rest of these texts not being published. But equally, it spawned a productive processing of doubt that ended in an embrace of the collateral damage of creative writing. I think now I've understood what it also means to scoot out of the frame: not only for me to gain distance from my subject in order to reclaim some dignity—as was the case with Sander before I finally wrote to him "Now I'm OK. Now the summer is over"—but for the writer to vacate the page, and let the work give rise to new judgments, different actions. Now I publish the text—enough with the bullshit.

One nuisance of identity politics is how cocksure and prescriptive it is, how it rushes, fatally, self-destructively, into the future. It might assume to tell me, for instance, how Michael's and my respective positions in the identity matrix demand we relate to one another. I hate to think I would have never written to him, or about him, or that I would have never got to the point where I could find out from him what this project actually means to him—in what ways it is significant, or, crucially, not significant. Naturally, he is not invested in the book in the same way that I am. He has his own life, and bigger fish to fry, like getting out of prison. "I am so excited to finally leave this place," he wrote in September 2020, "I feel so nervous right now, and I don't think that feeling will go away until I hear my name called to report to the R & R."

R & R stands for Receive & Release. It's a bus that shuttles people in and out of the facility. He signed off his last ever letter from prison:

"P.S. Good work on the essay, thank you for putting me in it."

154

ENDNOTES

Notes to CHAPTER 2—Doing Time

1 Janet Malcolm, *The Journalist and the Murderer* (New York: Knopf, 1990), p. 141.
2 Bettina Bergo, "Emmanuel Levinas," *The Stanford Encyclopedia of Philosophy*, plato.stanford.edu/archives/sum2015/entries/levinas.
3 Friedrich Nietzsche, *On the Genealogy of Morality*, trans. Carol Diethe (Cambridge, UK: Cambridge University Press, 1994), p. 25.
4 See, for instance, Jacques Derrida, *Of Grammatology* (Baltimore: Johns Hopkins University Press, 1998).
5 Gilles Deleuze, *Difference & Repetition* (London: Continuum, 2004), p. 44.
6 Louis Althusser, "Ideology and Ideological State Apparatuses (Notes Towards an Investigation)," Marxists.org, originally published in *La Pensée* 151 (1970), www.marxists.org/reference/archive/althusser/1970/ideology.htm.
7 "Crisis," Online Etymology Dictionary, www.etymonline.com/index.php?term=crisis.
8 Althusser (see note 6).
9 Russell K. Robinson, "Masculinity as Prison: Sexual Identity, Race, and Incarceration," *California Law Review* 99 (2011): 1311.
10 "California 'Carjacking' Laws Penal Code 215 PC," Shouse California Law Group, www.shouselaw.com/carjacking.html#3.3.
11 "Update on the California Prison Crisis and Other Developments in State Corrections Policy," *Berkeley Journal of Criminal Law* 14 (2009): 164.
12 Ibid.

13 Martin Luther King, *A Testament of Hope: The Essential Writings of Martin Luther King* (London: Harper Collins, 1991), p. 117–18.

14 Frantz Fanon, *Black Skin, White Masks* (London: Pluto Press, 2008), p. 172.

15 Robinson, *Masculinity as Prison* (see note 9), p. 1312.

16 Sara Ahmed, *The Cultural Politics of Emotion* (New York: Routledge, 2004), p. 39.

17 Nietzsche, *Genealogy* (see note 3), p. 35.

18 Ibid., p. 38.

19 "Correspondence," OED.com (subscription only).

20 Ingeborg Bachmann and Paul Celan, *Correspondence: Ingeborg Bachmann and Paul Celan* (London: Seagull, 2010), p. 195.

21 Ibid., p. 258.

22 Ibid., p. 264.

23 Ibid., p. 193.

24 Chantal Mouffe, *Deconstruction and Pragmatism* (London / New York: Routledge, 1996), p. 4.

25 Manuel Puig, *Kiss of the Spider Woman* (London: Vintage, 1991), p. 202.

26 Ibid., p. 113.

27 Ibid., p. 114.

28 Ibid, p. 114; italics added.

29 Ibid., p. 219.

30 Jean Genet, *The Thief's Journal* (London: Penguin, 1988), p. 5.

31 Jean Genet, *Prisoner of Love* (New York: New York Review Books, 2003), p. 6.

32 Simon Critchley, "Writing the Revolution: The Politics of Truth in Genet's Prisoner of Love," in *Ethics, Politics and Subjectivity* (London: Verso, 1999), p. 41.

33 Genet, *Prisoner* (see note 31), p. 300.

34 Critchley, "Writing the Revolution" (see note 32), p. 47.

35 Barbara Johnson, "Using People: Kant with Winnicott," in Marjorie Garber et al., eds., *The Turn to Ethics*

(New York / London: Routledge, 2000), pp. 47–63, here pp. 55, 56, 62.

36 Ibid., p. 58.
37 "Penpal Guidelines [sic]," Bent Bars Project, www.bentbarsproject.org/penpal-guidelines
38 "Pen pal Guidelines," Black & Pink, www.blackandpink. org/wp-content/upLoads/BP-Writing-to-LGBTQ- Prisoners-as-a-Group.pdf.
39 Althusser, "Ideology" (see note 6).
40 Critchley, "Writing" (see note 32), p. 41.
41 Genet, *Prisoner of Love* (see note 31), p. 6.
42 Critchley, "Writing" (see note 32), p. 47.
43 Bachmann and Celan, *Correspondence* (see note 20), p. 264.
44 Denise Riley, *Time Lived, Without Its Flow* (London: Capsule, 2012), p. 25.
45 Ibid., p. 66.
46 Ibid., p. 59; italics added.
47 Ibid., p. 49.
48 Ibid., p 19.
49 Fanny Söderbäck, "Revolutionary Time: Revolt as Temporal Return," *Signs* 37, no. 3 (2012).
50 Deleuze, *Difference & Repetition* (see note 5), p. 90.
51 Judith Butler, *Gender Trouble* (London / New York: Routledge, 1990).
52 Söderbäck, "Revolutionary Time" (see note 49), p. 309.
53 Antonio Negri, *Pipeline: Letters from Prison* (Cambridge: Polity, 2014), p. 6.
54 Ibid., p. 107.
55 Mara Lee, *När Andra skriver: Skrivande som motstånd, ansvar, och tid* (Gothenburg: Glänta Produktion, 2014), p. 67. Line breaks in the original. My translation throughout.
56 Denis Hollier, *Absent Without Leave: French Literature Under the Threat of War* (Cambridge, Mass. / London: Harvard University Press, 1997), p. 4. Hollier is quoting

from Marguerite Duras, *The War: A Memoir* (New York: The New Press, 1994).

57 Riley, *Time Lived* (see note 44), p. 35.

58 Lee, *När Andra skriver* (see note 55), p. 242.

59 Ibid., p. 226.

60 "Recidivism," Merriam-Webster.com, www.merriam-webster.com/dictionary/recidivism.

61 Philip Goodman, "Another Second Chance: Rethinking Rehabilitation through the Lens of California's Prison Fire Camps," *Social Problems* 59, no. 4 (November 2012): 437–58, here p. 440.

62 Sara Ahmed, "A Phenomenology of Whiteness," *Feminist Theory* 8 (2007): 149–68, here p. 165.

63 Lee, *När Andra skriver* (see note 55), p. 227.

64 Ahmed, "A Phenomenology" (see note 62), p. 160.

65 "CDCR Presents 'Pathways to Rehabilitation' Project Roadmap to Rehabilitation Oversight Board," CDCR Today, September 4, 2008, accessed April 19, 2016, cdcrtoday.blogspot.co.uk/2008/09/cdcr-presents-pathways-to.html (site discontinued).

66 Joan Petersilia, "Understanding California Corrections: Summary," Center for Evidence-based Corrections, University of California, Irvine, ucicorrections.seweb.uci.edu/files/2013/06/cprcsummary.pdf.

67 Michelle S. Phelps, "Rehabilitation in the Punitive Era: The Gap Between Rhetoric and Reality in U.S. Prison Programs," *Law & Society Review* 45, no. 1 (March 2011): 33, here p. 40.

68 Ibid., p. 41.

69 Ibid., p. 37.

70 Goodman, "Another Second Chance" (see note 61), p. 439.

71 "Rehabilitation—Correctional Programs in the United States," Law.JRank.org, Law Library—American Law and Legal Information, law.jrank.org/pages/1935/

Rehabilitation-Correctional-programs-in-United-States.html.

72 CDCR, Recidivism Report Archive, www.cdcr.ca.gov/research/archived-research.

73 "Pell Grants to Bring College Back to Prison: US Is 'a Nation of Second Chances," *The Guardian*, by Dasha Lisitsina, August 2, 2015, www.theguardian.com/us-news/2015/aug/02/pell-grants-college-classes-prison-education.

74 Goodman, "Another Second Chance" (see note 61), p. 438.

75 Ibid., pp. 438–39.

76 Aiwah Ong, *Neoliberalism as Exception: Mutations in Citizenship and Sovereignty* (Durham, NC: Duke University Press, 2006).

77 Goodman, "Another Second Chance" (see note 61), p. 439.

78 Phelps, "Rehabilitation in the Punitive Era" (see note 67), pp. 40–1.

79 Petersilia, "Understanding California Corrections" (see note 66).

80 Michelle Alexander, "The New Jim Crow," in Richard Delgado and Jean Stefancic, eds., *Critical Race Theory* (Philadelphia: Temple University Press, 2013), p. 276.

81 Goodman, "Another Second Chance" (see note 61), p. 438.

82 "California's Three Strikes Sentencing Law," Courts.ca.gov, California Courts: The Judicial Branch of California, www.courts.ca.gov/20142.htm.

83 Lisa T. Quan, Sara Abarbanel, and Debbie Mukamal, "Reallocation of Responsibility: Changes to the Correctional System in California Post-Realignment," Stanford Law School, Stanford Criminal Justice Center, January 31, 2014, law.stanford.edu/publications/reallocation-of-responsibility-changes-to-the-correctional-system-in-california-post-realignment.

84 Goodman, "Another Second Chance" (see note 61), p. 439.
85 Fanon, *Black Skin, White Masks* (see note 14), p. 171.
86 Alexander, "The New Jim Crow" (see note 80), p. 274.
87 Conversation with Midge Purcell from the Urban League, March 30, 2016.
88 "California Ban the Box Law Takes Effect," Xpert HR, July 1, 2014, www.xperthr.com/news/california-ban-the-box-law-takes-effect/12628.
89 "Assembly Bill 396: Rental Housing Discrimination," California Legislature 2015–2016 session, leginfo.legislature.ca.gov/faces/billTextClient.xhtml?bill_id=201520160AB396.

Notes to CHAPTER 3—Using People

1 Denis Hollier, *Absent Without Leave: French Literature Under the Threat of War* (Cambridge, MA: Harvard University Press, 1997), p. 4. Hollier is quoting from Marguerite Duras, *The War: A Memoir* (New York: The New Press, 1994).
2 Janet Malcolm, *The Journalist and the Murderer* (New York: Knopf, 1989), p. 160 and p. 1.
3 Barbara Johnson, "Using People: Kant with Winnicot,'" in Marjorie Garber et al., eds., *The Turn to Ethics* (New York / London: Routledge, 2000), pp. 47–63, p. 55.
4 An edited version of my correspondence with Bass and Mohaiemen was published in *Protocollum* no. 3 (2016–17).
5 All quotes from Thomas Mallon, "Theirs Truly: The Lowell-Bishop Letters," *The Atlantic* (April 2009), www.theatlantic.com/magazine/archive/2009/04/theirs-truly-the-lowell-bishop-letters/307315.
6 Robert Lowell, "Dear Elizabeth," *The New Yorker* (December 13, 2004), www.newyorker.com/magazine/2004/12/20/dear-elizabeth.

7 Elizabeth Hardwick, *Seduction and Betrayal* (London: Faber, 2019).

8 Robert Lowell, "Dolphin," in *The Dolphin* (New York: Farrar, Straus & Giroux, 1973).

9 Hilton Als, "The Art of Difference," *The New York Review of Books* (June 2017), www.nybooks.com/articles/2017/06/08/diane-arbus-art-of-difference/.

10 Ibid.

11 Coco Fusco, "Decades of Identity Politics," *Texte zur Kunst* 107 (September 2017): 118.

12 See, for instance, Alex Greenberger, "'The Painting Must Go': Hannah Black Pens Open Letter to the Whitney About Controversial Biennial Work," *ARTnews,* March 2017, www.artnews.com/artnews/news/the-painting-must-go-hannah-black-pens-open-letter-to-the-whitney-about-controversial-biennial-work-7992.

13 Coco Fusco, "Censorship, Not the Painting, Must Go: On Dana Schutz's Image of Emmett Till", Hyperallergic, March 27, 2017, hyperallergic.com/368290/censorship-not-the-painting-must-go-on-dana-schutzs-image-of-emmett-till.

ACKNOWLEDGMENTS

I am grateful to the friends who have thought with and against me during the writing of this book: Tank, Bella, Skye, and Rosanna Mclaughlin, who has been a formidable reader and editor throughout. Thanks to Mara Lee, Naeem Mohaiemen, Chloë Bass, Peter Voss-Knude, Alexander Lind, and Ellie Ga for your correspondences and conversations, which I've used as material. For the first draft of the essay "Doing Time" I was helped by Nina Power and David Crowley at the Royal College of Art, and greatly supported, as always, by Christopher Whitfield.

Thanks Göran Dahlberg and *Glänta* for the Swedish debut of "Doing Time" in 2016–17, and for commissioning an earlier version of "Using People" for *Glänta*'s lecture series; and Ida Linde and Biskops Arnö for the invitation to speak at the 2018 Debutantseminar for which I wrote a first draft of "Skin Hunger."

Lastly, thanks to Aaron Bogart and Floating Opera Press for supporting this publication, and, of course, most of all, thank you Michael for your friendship, compassion, and time.

ABOUT THE AUTHOR

Kristian Vistrup Madsen is a Berlin-based writer. He holds degrees from Goldsmiths, University of London, and the Royal College of Art, and is a frequent contributor to magazines such as *Artforum*, *Frieze*, *Mousse*, and *Kunstkritikk*.